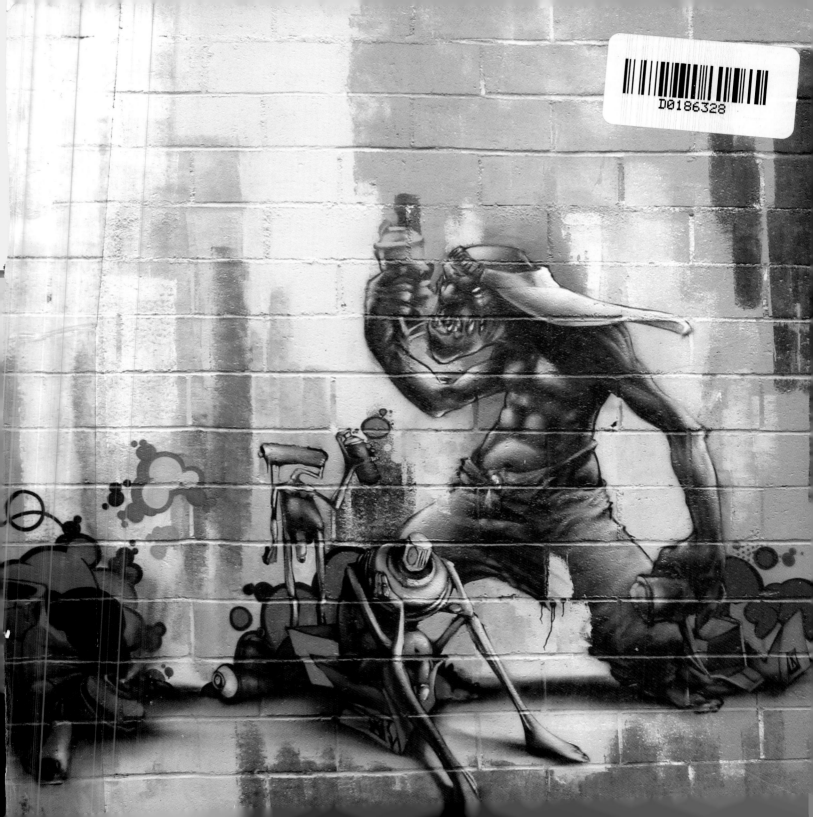

The publishers wish to make it clear that they do not condone defacing public property with graffiti.

Translation by Translate-A-Book, Oxford

Design and creation: GRAPH'M/Nord Compo, France

ISBN: 978-2-7528-0181-4

Copyright registration: April 2005

Printed in Singapore by Tien Wah Press

www.silverbackbooks.com

Silverback Books, Inc.
55 New Montgomery Street, #500
San Francisco, CA 94105

graffiti

sandrine pereira

contents

art or vandalism?

If someone mentions graffiti, what's your reaction? Most likely you'll think of scrawls on urban buildings: vandalism, degradation of the environment. Maybe you'll also have thought of art, frescoes, painting, urban culture. Tagging is the chronic itch of the graffitist to go and leave his *nom de plume*, the writer's signature, in a prominent place in town. However, graffiti is not always improvised: as pieces have become bigger and more complex, they require a premeditated process, the first stage of which is a paper sketch of the intended design. However you feel about it, tagging and graffiti are now integral to our everyday visual world, not only on urban walls, trains and subways, but in the fashion industry, publicity, films, the art world and the Internet.

Graffiti as we know it appeared in urban areas, especially New York, some twenty years ago and the activity has taken hold in an extraordinary way. Its detractors have always described it as the simple, inarticulate expression of young drop-outs from the most dis-advantaged social classes. This is a fundamental mistake since graffiti has transcended not merely socio-economic barriers but also those of race, culture and religion.

People have also pigeon-holed graffiti as a form of rebellion but it has taken many forms. What started on the steel sides of a railway carriage can end up showcased in the world's top museums. Graffiti can denounce, demand, amuse. Why? Simply because it is a means of expression in its own right, an artistic movement based on multiple influences with its protagonists hailing from a huge range of backgrounds.

The techniques used are as varied as the graffiti artists, or 'writers' as they call themselves, and range from *bubble style* to *wild style* via tagging and *stencil graffiti*. This is what makes graffiti more than just vandalism; it's very much a living art-form finding its inspiration far from academies and traditional schools.

Writing or drawing on walls is, in fact, one of mankind's oldest activities! Now, this activity has evolved into a cultural movement which has found a place in modern society.

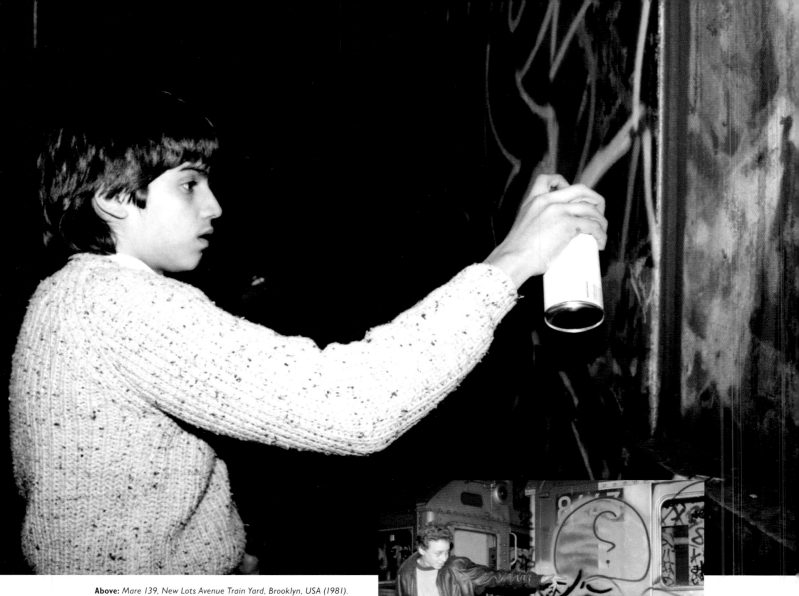

Above: *Mare 139, New Lots Avenue Train Yard, Brooklyn, USA (1981).*
Opposite: *Min One, City Hall Layup, New York City, USA (1982).*
Right-hand page: *Graffers operate in a very different world to studio artists. Favourite sites include derelict buildings and waste ground.*

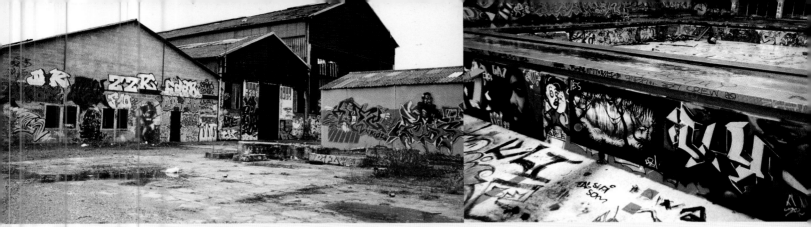

in the
beginning...

graffiti, definitions

Where, when and how did graffiti start? You may think you know the answer – in New York – it appears so obvious … Don't you believe it! There's more to it than that. One thing is certain: it's older than the invention of towns and cities, since examples existed even on the walls of prehistoric caves! You've probably never considered cave paintings as graffiti!

To begin with, let's forget the when and the where – and even the how – and consider for a moment the word 'graffiti'. A glance in the dictionary shows us that graffiti is 'an inscription or drawing hastily produced by hand on a wall'. Somewhat simplistic, graffitists will conclude. But justice is done a few lines further down, with the definition of 'graffiti': noun signifying 'a pictorial composition based on handwriting and sprayed on a wall or other surface'. There's also mention of the 'writer': 'person or artist using spraycans to produce a design'.

This is a highly complimentary definition of an activity that many feel pollutes and disfigures our urban areas. Unfortunately for the detractors, this same dictionary seems to dig its heels in and accord graffiti the status of a cultural and artistic movement with the ultimate, upgraded definition found under 'graffitist': 'person who paints graffiti on walls; artist seeking self-expression through graffiti, tagging or spraying'. There you have it! The terms 'tagging' and 'spraying' are associated with 'artist' and 'self-expression'. Bad news for all those city authorities and transport cleaning services who invest massive sums every year in anti-graffiti campaigns! The

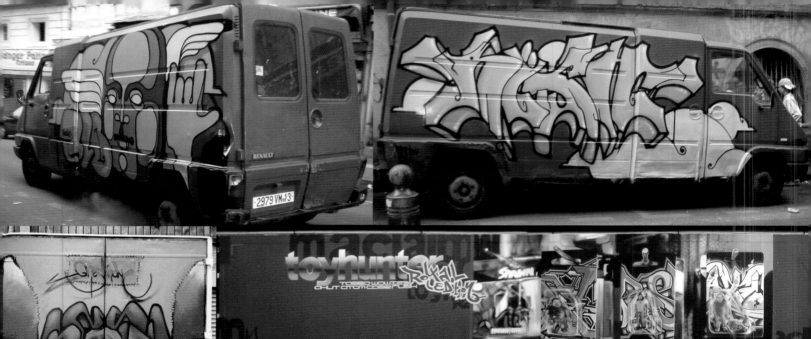

Not only walls but trucks! Graffers enjoy exploring different possibilities in their environment.
Above: top, *1st Truck: Diablo-Rish (2004)*; bottom, *2nd Truck: Simone (2004)*, *3rd Truck: Atom-Wow 123-Akut-Case-Rusk-Tasso, Toyhunter (2003)*.
Left-hand page: 1st band, left, *Rusk*; right, *Simone*; 2nd band: *Yoda*; 3rd band: *Trybe*; 4th band: *Reso*.

reader can rest assured that these definitions come from one of the most famous dictionaries and not from some primer of underground culture.

As if that wasn't surprising enough, you can check in a dictionary from the early 1990s and find astonishingly similar definitions of the same words. Clear proof, on the one hand, of the ambivalent reactions graffiti has always aroused, and, on the other, of the high profile – and consequent recognition of a kind – it has enjoyed. The paradox illustrates the difficulty of classifying it as either art or vandalism.

However, let's go back to the basic definition of 'graffiti', since we're not talking here about spraying but inscriptions on a wall. Obviously the most sophisticated graffiti goes way beyond a simple tag. I wonder if aficionados of *bubble style* have ever imagined for an instant that their type of graffiti may be descended from the rock-carving habitually practised by early people on their cave walls? There's an amusing parallel here, since the 'young vandals' – the taggers – multiplying their signatures over the walls of our dwellings are doing exactly what their ancestors did! Aren't they motivated by the same desire to

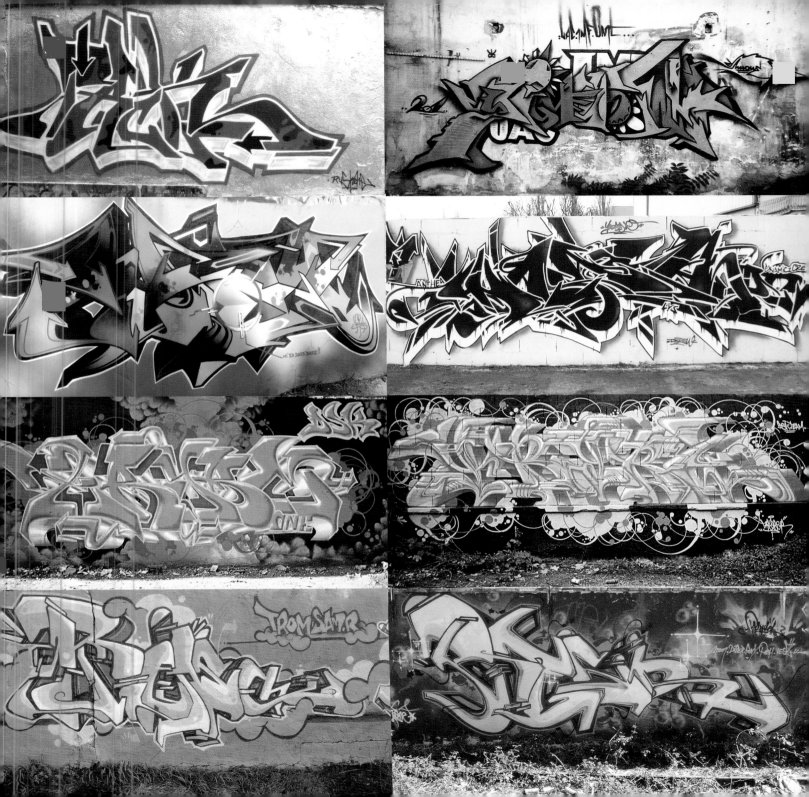

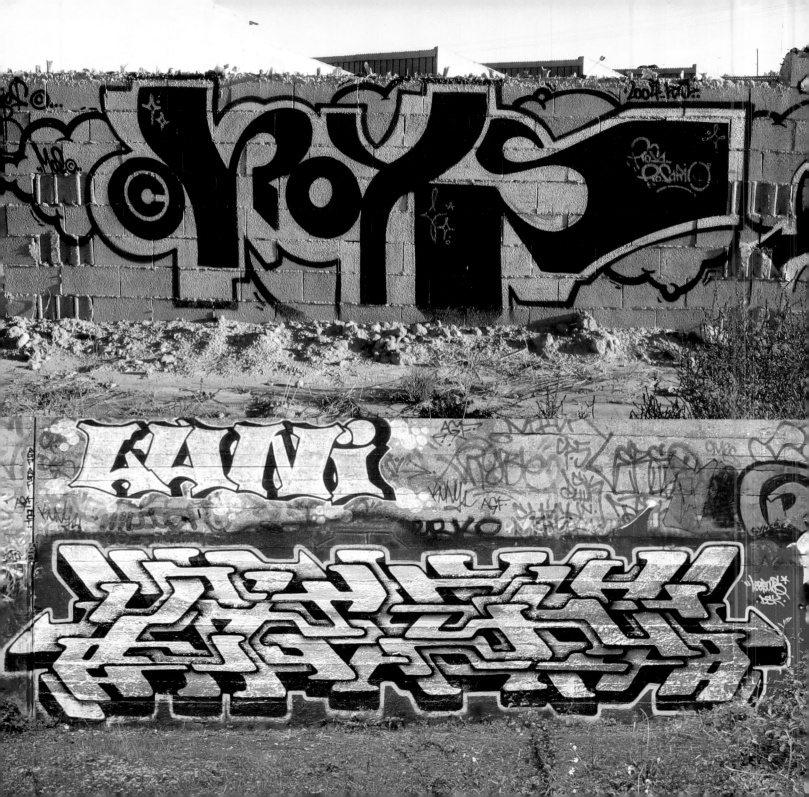

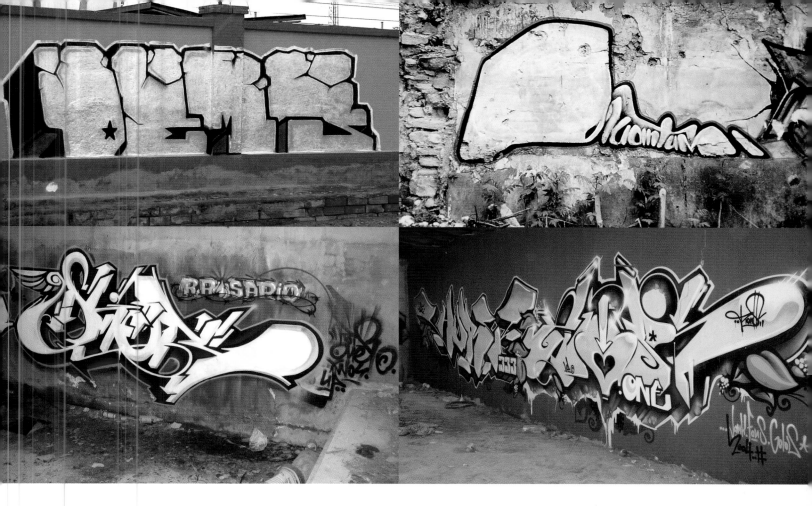

leave their mark behind? People have always expressed their desires, concerns and hopes using whatever surfaces came to hand: stone, caves, walls. The common thread of graffiti can be said to connect all the eras of human history.

Incidentally, where does the word come from? The term 'graffiti' is actually an Italian import. The different etymologies are fascinating in that they shed light on our equivocal relationship with these 'wall inscriptions'. 'Graffiti' derives from *graffitia*, meaning either 'scratching' or

'stylus used on wax tablets'. The authors of *Le Livre du graffiti* (see bibliography) push the analysis even further, back to the Latin word *graphium* denoting a scribing tool. And *graphium* itself comes from the Greek *graphein*, variously signifying 'to draw', 'to paint', and 'to write'! So, delving into the earliest origins of the term, we learn that the word covers several types of writing and inscribing.

Walls, walls, and more walls …
Left-hand page: Top, *Roys*, Black Silver (2003); bottom, *Legz*.
Above: Left to right, *Dems; Simone; Roys; Hurt-Roys*.

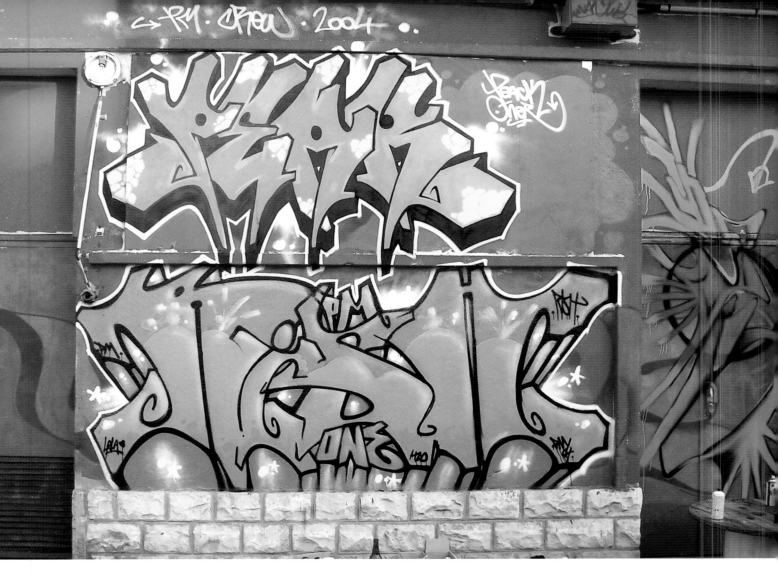

Another interesting fact is that *sgraffito* is not a medieval version of tagging but a technique of wall decoration very much in fashion during the Renaissance.

Impossible, then, to think of graffiti just as an invention of the twentieth-century American ghetto. It would be pretentious to label every daub on a building a work of art, yet, since the dawn of history, people have enjoyed graffiti as a pastime and means of expression.

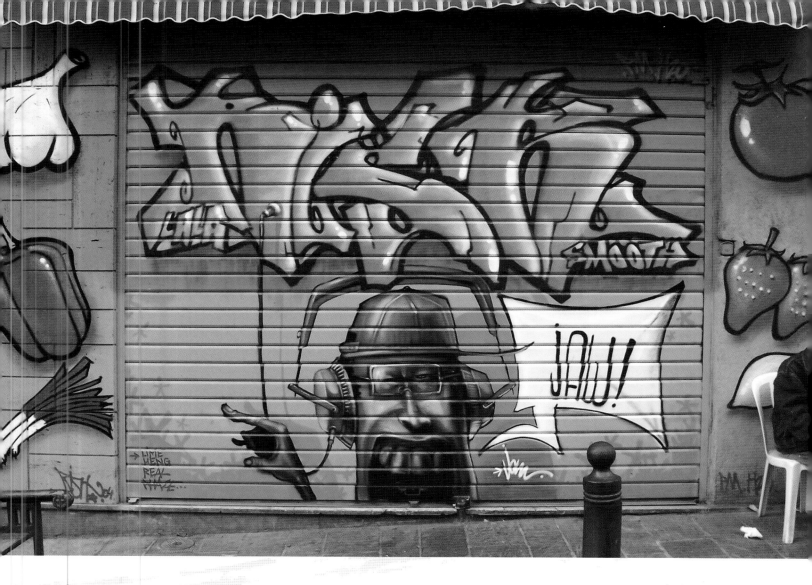

Other sites for graffiti include the steel shutters protecting businesses.
To prevent unauthorised tagging, traders commission frescoes from selected
graffers; they reap the added benefit of having their frontages enhanced.

Left-hand page: *Peack-Rish (2004).*

Above: *Rish-Jaw (2004).*

a **brief history** of **graffiti**

What has been the purpose of these inscriptions made since prehistoric times? Quite likely to leave a record of an individual existence on an enduring medium. The study of graffiti throughout history shows that, from the Neolithic period onwards, nomads left traces of their survival and successful passage by scratching signs on rocks. Scribbling your name, linked to your partner's, on the walls of a museum lavatory is not the prerogative of modern tourists. Three thousand five hundred years ago, two genial scribes, presumably aroused to a fever-pitch of passion by their social activities, left their marks in ink under the Egyptian pyramids during a visit. In ancient Athens, the walls served as a safety-valve for citizens' demands and fantasies. Under the Roman Empire, satirical, amorous or electoral tags flourished on the walls of Pompeii. The rash of inscriptions provoked indignation, with one scribe writing: 'I'm astonished, wall, that you haven't collapsed under such an unbearable weight of scribblings.' In the catacombs where Christians, persecuted by the Romans, took refuge, their watchwords and symbols carved into the rock also served as cryptic messages for the rest of the community. During the sixteenth-century Wars of Religion, when Protestants sacked a church, they took pains to leave behind a written record of their recriminations by carving a mutilated image with messages such as: 'The remains of this rare piece … smashed by the wrath of the heretics.'
During the eighteenth century, the so-called Age of Enlightenment which heralded the horrors of the French

Revolution, prisoners in the French king's prisons prophesied through their writings the approaching rebellion. A typical message at Loches dates from 1758: 'Soon we shall overthrow these great walls … and sweep away the torments invented by kings too feeble to contain a people demanding its liberty.' Paradoxically, other walls,

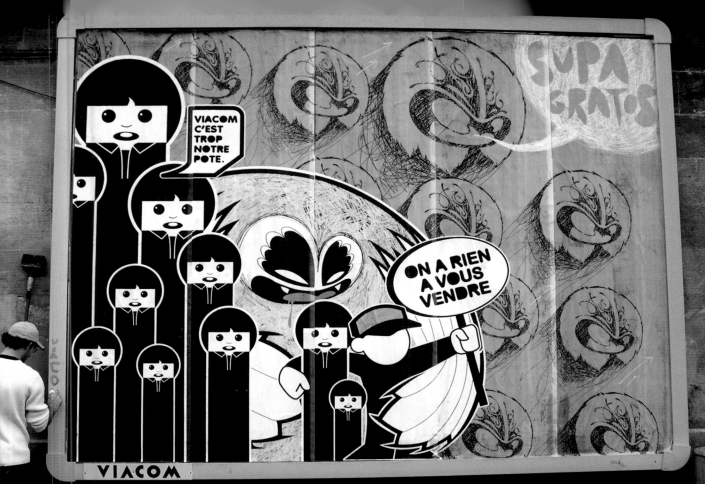

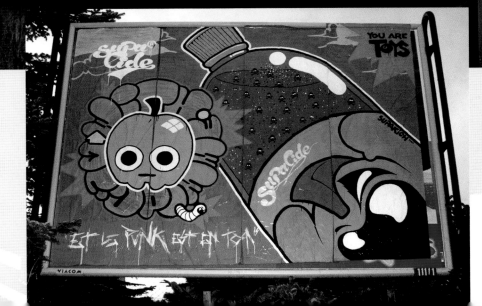

Left-hand page: *A little personal touch to round things off; Alëxone (2003).*

Graffers also have a sense of humour; by hijacking advertising sites they express their feelings about our consumer society.

Above: *Supakitch-Opt-Eko (2004).*
Opposite: *Supakitch (2004).*

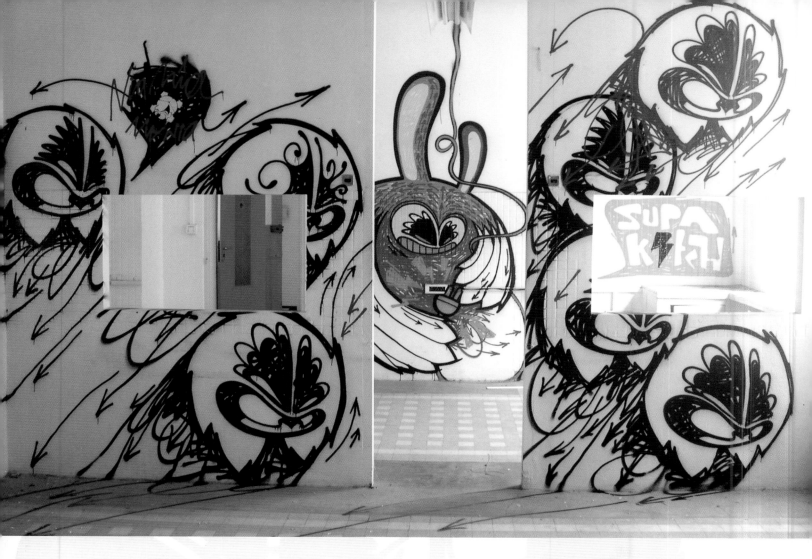

particularly those of churches and cemeteries, began to host risqué tags revealing the emergence of a permissive and libertine sub-culture: 'Madame la Comtesse/asks a halfpenny a caress./But for a penny/she'll do anything for any.'

In the 1800s, the golden age of French literature, we find references by well-known authors to graffiti, collected as they walked about town. Honoré de Balzac recalls, in *Ferragus*, a time when 'there wasn't a wall in the Rue Pagevin that didn't boast a dirty word'.

From plain graffiti to figurative work is only a short step.
Above: *Supakitch (2004).*
Right-hand page: Left, *Supakitch-Koralie (2004)*; top right, *Supakitch-St Arsky-Mkan-Siao (2004)*; bottom right, *Supakitch (2004)*.

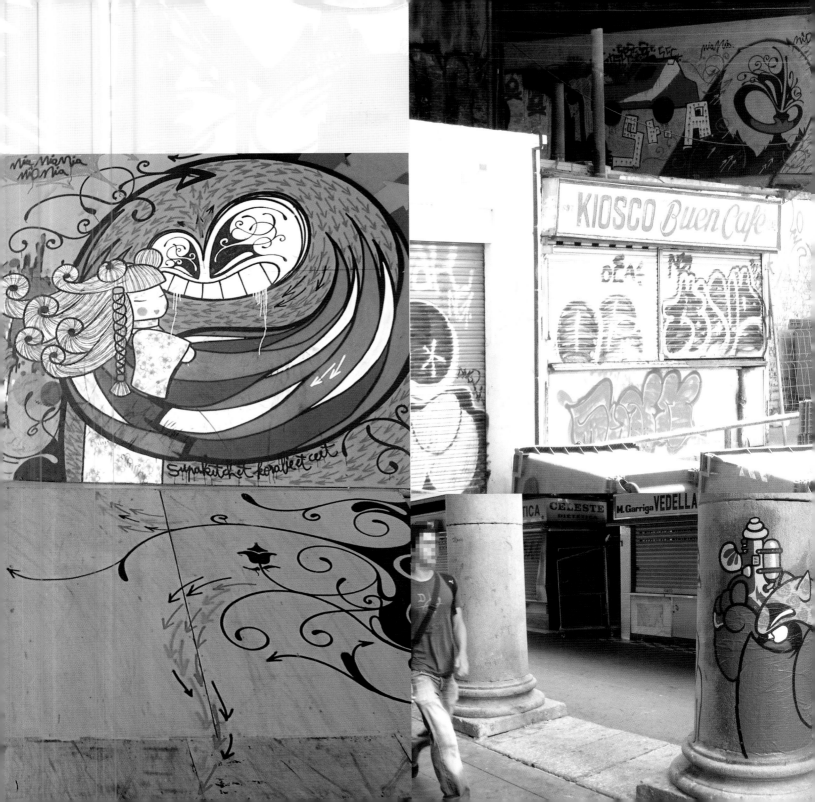

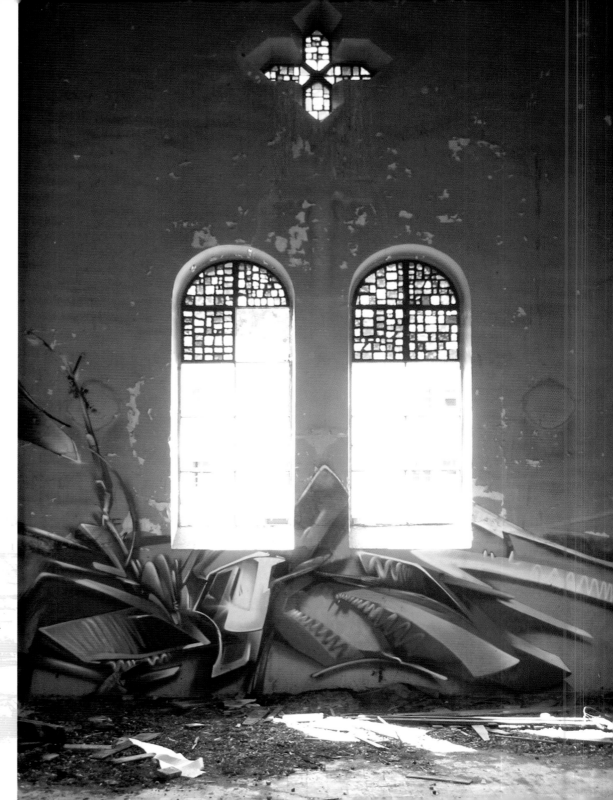

Opposite: *A chapel revisited by Brusk (2004).*

Right-hand page: *A message influenced by the contemporary mood; Alëxone, No War (2003).*

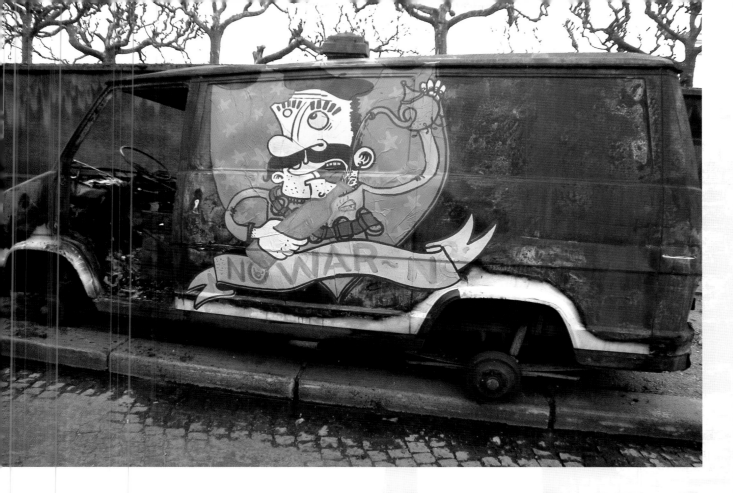

And even the illustrious Victor Hugo became a tagger for a moment when he and his mistress carved their initials on the walls of a tower in Jersey.

Finally, graffiti, once a phenomenon of the working classes, acquired snob-value once it was taken up by the Surrealists, from Picasso to Picabia. Emerging from anonymity, it took centre stage in the salons of the 1920s. What had been popular scrawl received its seal of approval in 1933 with the publication by the gifted French photographer, Brassaï, of a photo-essay on graffiti. During the Second World War, the Nazis employed it as a weapon, smearing the walls with their hate-filled propaganda against the Jews and other enemies of the Third Reich. The French Resistance replied in kind.

Street culture showed itself at its most imaginative during the 1960s and 1970s, a period of student and labour unrest throughout Europe. Wall slogans vied with one another for creativity. In France, for instance: 'Don't waste living earning it.' 'Don't work, f***' 'No gods, no masters.' And of course, the memorable 'Under the pavements, the beach'.

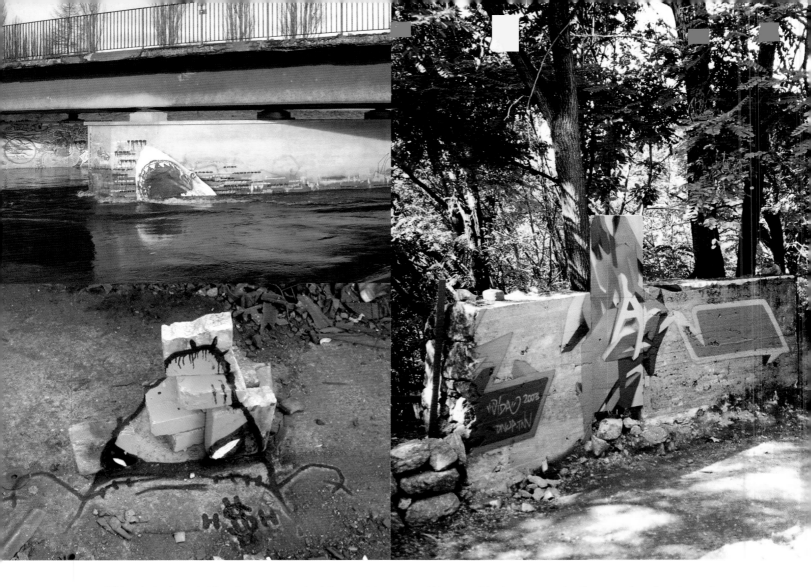

This wind of revolt blew from one end of the world to the other. Even as far away as China, where opponents of Mao's Cultural Revolution risked their lives to post their celebrated *dazibaos* – anti-Maoist pamphlets – on the walls. The Berlin Wall became the focus of growing disillusionment in the East – slogans appeared on the Western side, but not on the Eastern, since freedom of expression had been banned in what was then the German Democratic Republic. When the Wall was toppled in 1989, the inscriptions became worth their weight in gold. Did the fact that they now had financial value confirm their artistic worth? In fact, it was more a case of

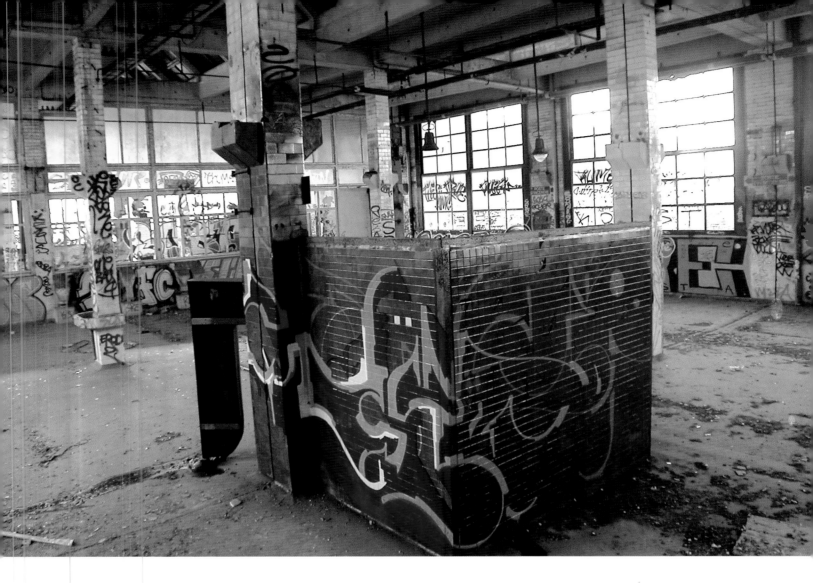

buying a piece of history – the prices of graffiti art were already soaring in the world's industrialised capitals.

All this was a good omen for the art form and a foretaste of events in decades to come as a new kind of image began to adorn the walls of American ghettos. The era of modern graffiti art had arrived, the one we've known

Graff is everywhere: under bridges, in warehouses, out in the country!
Above: *Alëxone (2004).*
Left-hand page: Top left, *Tasso, Stille Wasser (2003);* bottom left, *Lksir (2003);* right, *Vida (2003).*

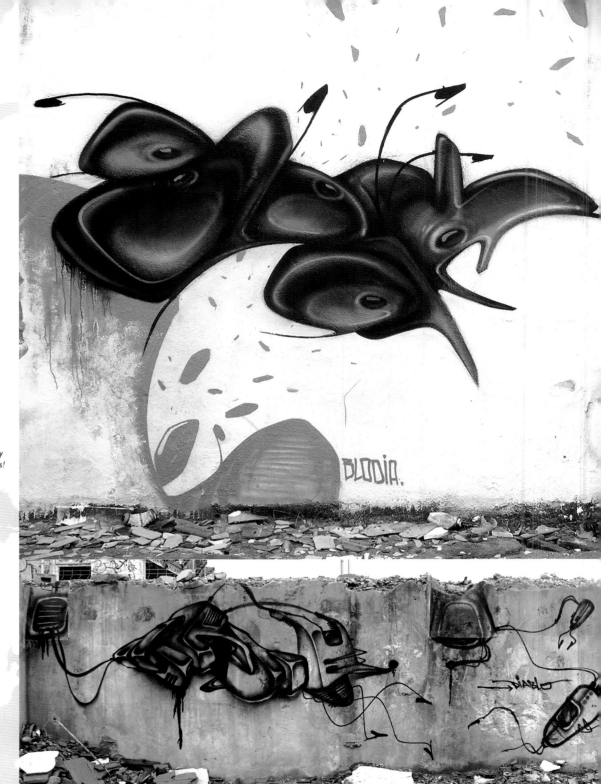

Bizarre designs, incomprehensible to ordinary mortals ... but not to graffers!
Opposite: *Diablo (2004).*

Right-hand page: Top, *Reso (2004)*; bottom, *Bom.K (2001)*; right, *Rish (2004)*.

for the last thirty or so years. The advent of the spraycan revolutionised writers' techniques and helped create a sort of counter-culture. From the New York subway to art galleries throughout the world, graffiti imposed its presence. As graffiti proliferated, it polarised public opinion and the media.

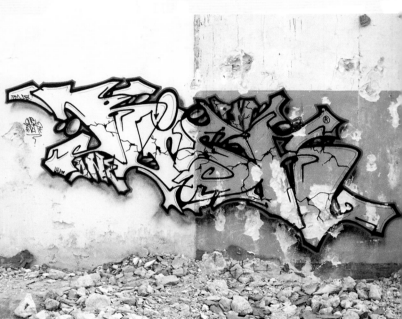

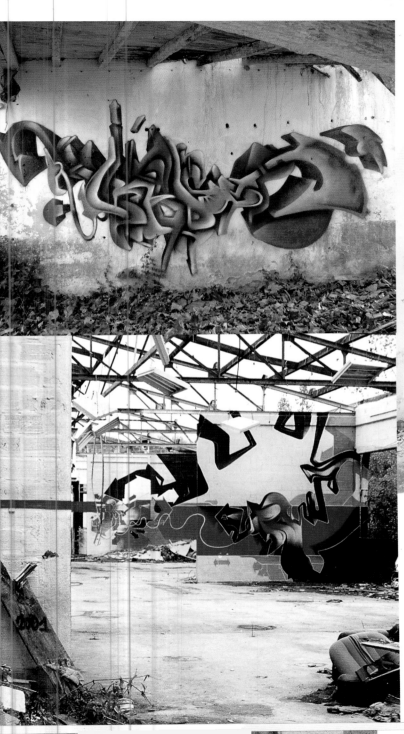

tagging hits

Originating from the less-advantaged social classes, taggers were usually Blacks or Hispanics, but they also included White kids. Their school was the street, and they were generally males. They signed themselves Keith Haring, Daze, Futura 2000, Lady Pink, Iz the Wiz, A-One, Toxic, Noc 167, Wasp, Crash, Blade, Fab 5, Taki 183. These weren't their real names of course, they were *tags* denoting writers; they produced 'pieces' (large-scale, multi-coloured, complex) and burners (high-quality pieces with crisp outlines and no drips).

They *bombed* entire rail cars and walls and vied to become *kings* and *queens* of the street. And while their tags smothered the walls, their names appeared all over magazines and invitation cards to art galleries. A bizarre and apparently unstoppable phenomenon faced the inhabitants of the Big Apple. The press were keen to recount New Yorkers' ambivalent attitude to tagging.

Column inches were devoted to comparing the vast sums swallowed up in the battle against graffiti and the prices fetched by graffiti artists' work – around 5,000 to 10,000 dollars each. For some, graffiti was a symbol of violence and aggression. Others saw it as something sacred, 'a cry of freedom uttered by a population of underdogs, the manifestation of a profound tribal movement, the very incarnation of the soul of the underground movement.'

It was even claimed that 'a train covered with graffiti entering a sinister subway station gave the impression of a lively Latin festival'!

In one of the first books on the subject (*The Faith of Graffiti*, 1974), the author, Norman Mailer, analysed the phenomenon in terms of the self-expression of a tropical people living in a modern, grey and monotonous environment and their determination to assert their sensuality and vivacity in the face of a technological world.

Critics also inveighed against its 'throw-away' nature since the life expectancy of tagging and graffiti, both illegal activities, was by definition extremely short. On the other hand, they admitted it had humour, inventiveness and dynamism. So they gave a cautious welcome to a new generation of artists soon to find their way into avant-garde museums and art galleries.

In the magazine *Art in America* (c. late 1970s), the writer, Wasp, confided, 'People must never stop writing their names.' Everyone, he claimed, wants the world to know he or she exists, where he or she comes from; it's either that, or drugs and stealing. The debate threw up much criticism of the vanity of the *kids'* art with its names splattered in huge letters, the shrieking colours, the *machismo* of the designs and the lack of subtlety.

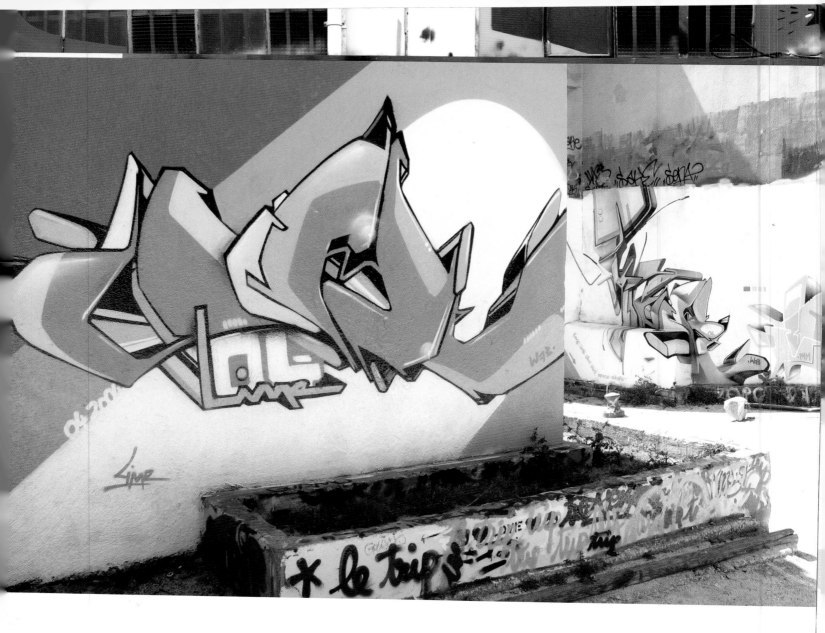

Above and right-hand page, top: *One graffer, two styles. Both examples are by Lime.*

Right-hand page: Bottom left, *Heng*; bottom right, *Peack.*

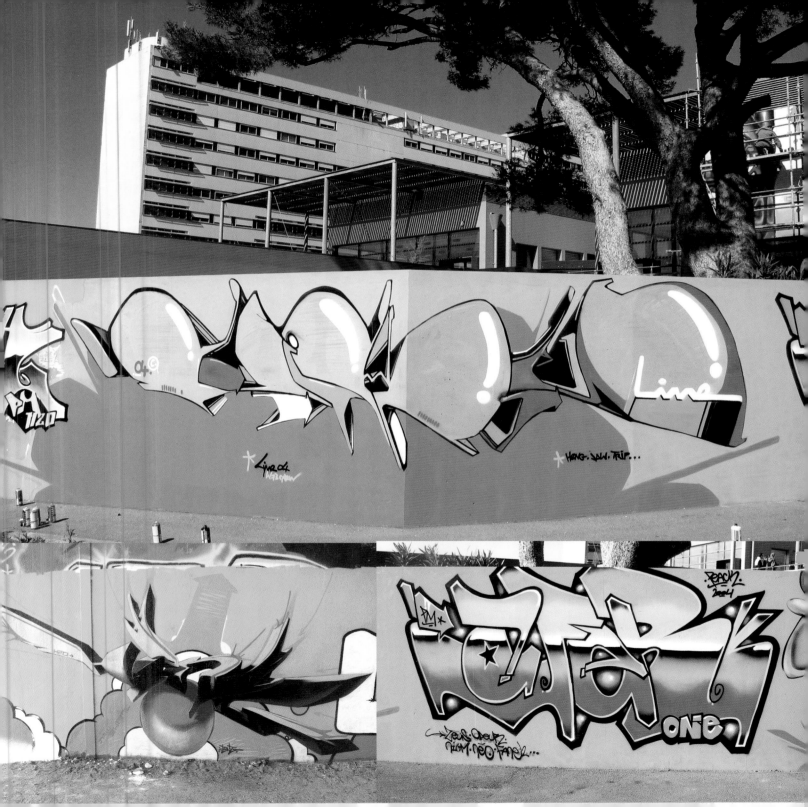

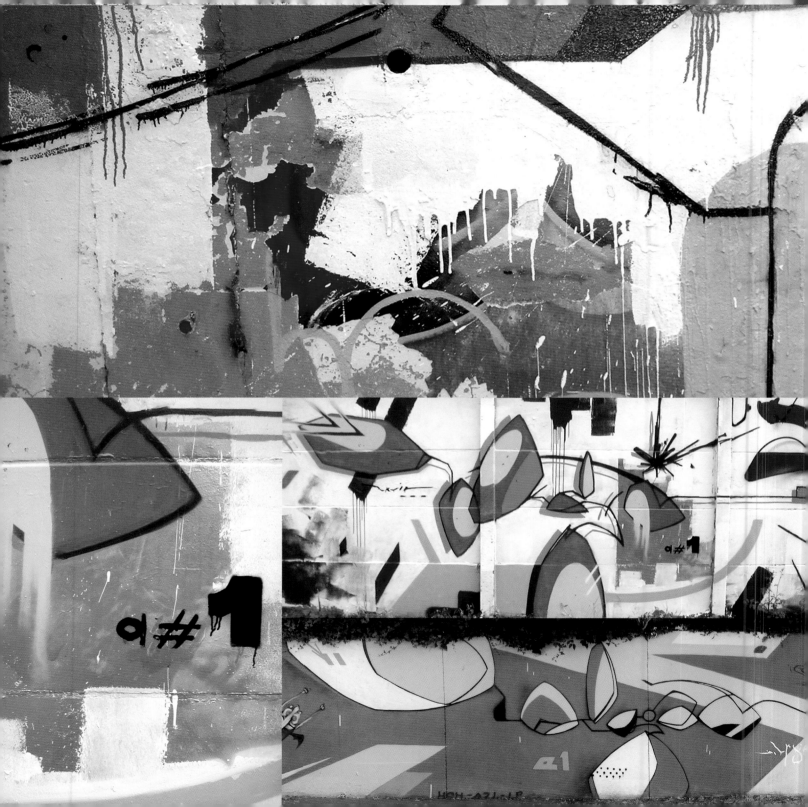

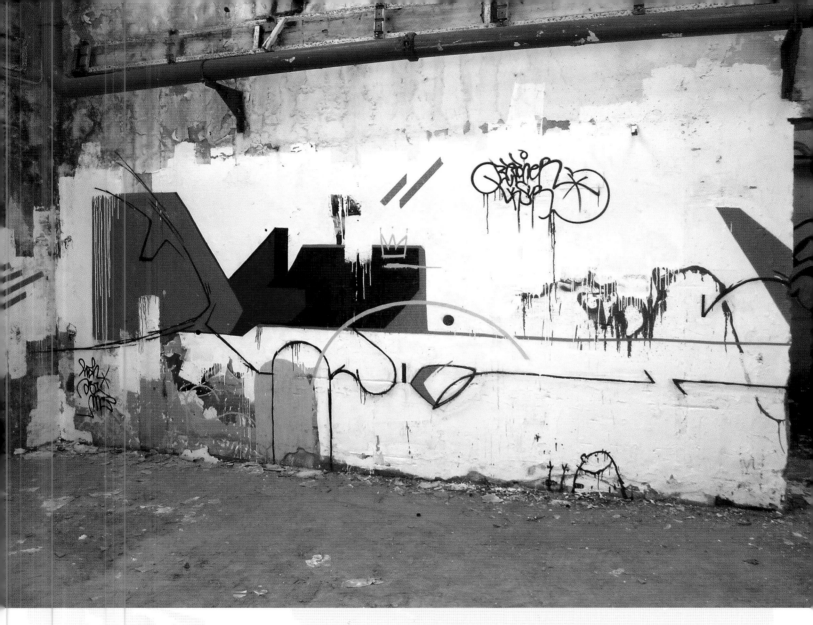

Left-hand page: *Details from graffs by Lksir (2004).*
Above: *Conceptual art? No – graffiti! Lksir and Obez.*

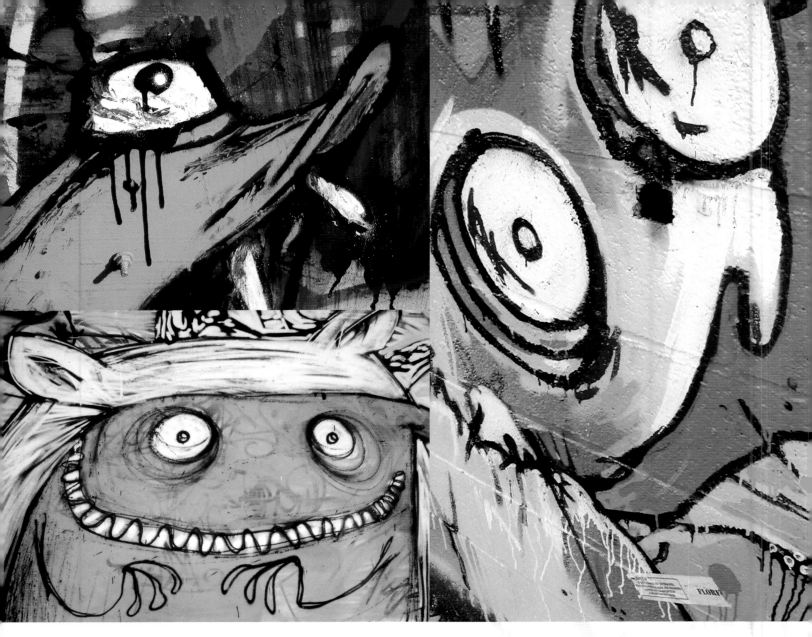

A perfect illustration of graffers' creative and inventive talent. Everything is by Lksir.

Above: Top, 2002; bottom, 1999; right, 2003.

Right-hand page: Left, 2002; top, 2004; bottom, 2003.

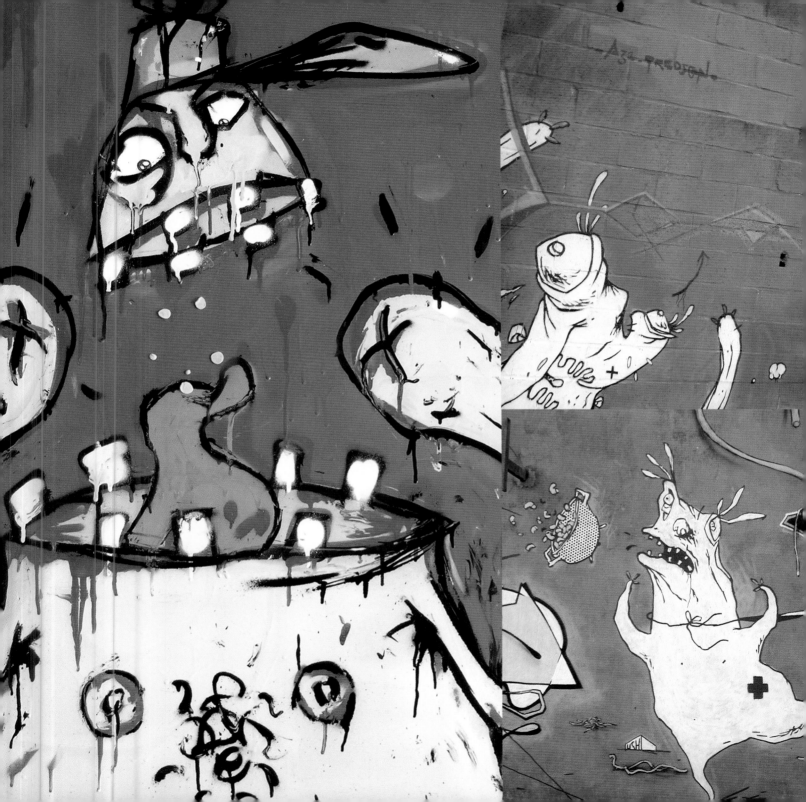

The old taggers knew all about Zulu Nation and would have been sure to be members, adopting the philosophy and codes laid down by its founder. Time has passed and new trends have enticed young people in other directions but Zulu Nation marked the high-water point of the hip-hop movement first in New York and, a few years later, in Europe. It started in the Bronx.

Zulu Nation, birthplace of **hip-hop**

In the 1970s, Afrika Bambaataa, ex-delinquent and member of as tough a gang as any the American ghettos produced, discovered the virtues of a peaceful existence and decided to found Zulu Nation after witnessing a brawl which cost the life of his best friend: he was shot nine times with a pistol. The allusion to the Zulus of South Africa is not fortuitous: Nelson Mandela was one of the icons who inspired this new homeland — as well as Martin Luther King and Malcolm X.

Being a Zulu meant adhering to a code that was both rigid and hard to apply in volatile urban areas. Every good Zulu owed it to himself to reject violence, alcohol and particularly drugs. Crack (cocaine) was causing havoc in large American cities. Members of the 'tribe' channelled their energies into developing their physical and mental abilities and setting themselves artistic challenges which allowed them to work off their aggressiveness and frustration.

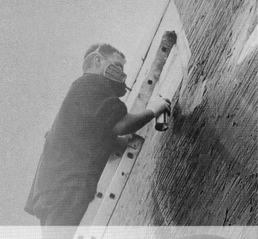

In this new world there were no frontiers. Blacks, Whites, Latinos, Arabs and Asiatics were all united in the same cause: to offer younger members positive role models to keep them on the straight and narrow. At its height, Zulu Nation had members all over America, in Brazil, Europe, and even South Africa, which still harboured the segregationist regime of apartheid.

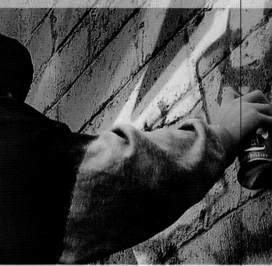

The favoured disciplines were dance (smurf, breakdance, uprock), rap music and graffiti – tagging was, as yet, not highly rated by extreme purists of the social harmony brigade. Now the debate as to whether tagging was art or an illegal activity also divided the movement. To keep the peace, prolific taggers were warned to leave their trademark on a virgin sticker, which they could then post wherever they wanted, paper being always easier to get rid of.

Dissected, analysed and described in minute detail by the specialists, Zulu Nation was suddenly ultra-cool, a social phenomenon that sucked in thousands of young people, before suddenly collapsing like a pricked balloon. The movement is a part of graffiti's history which made an immense contribution to launching hip-hop culture. Happily graffiti survived the decline, offering proof of its dynamic nature.

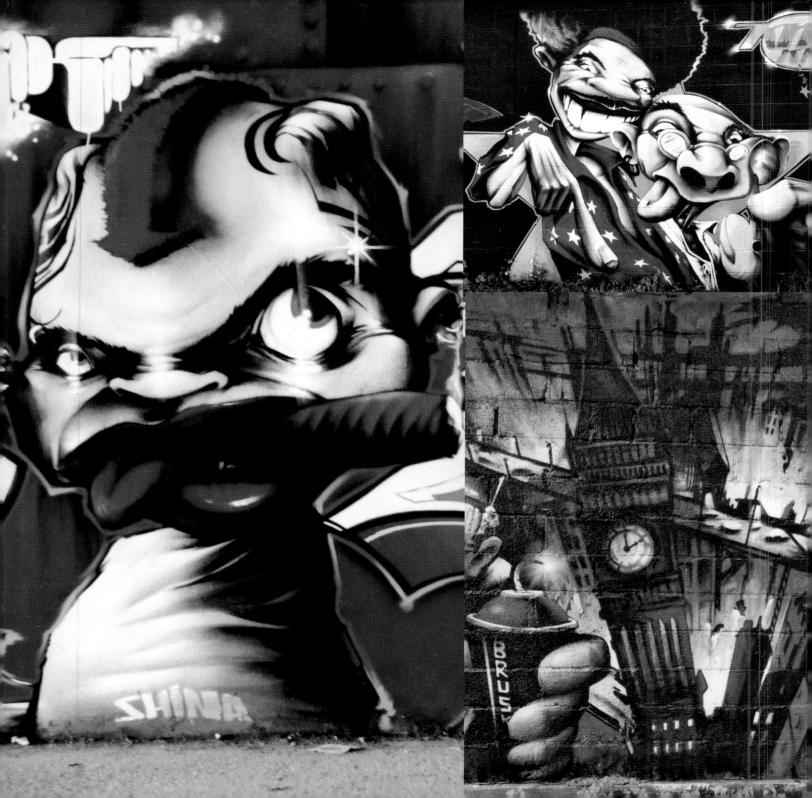

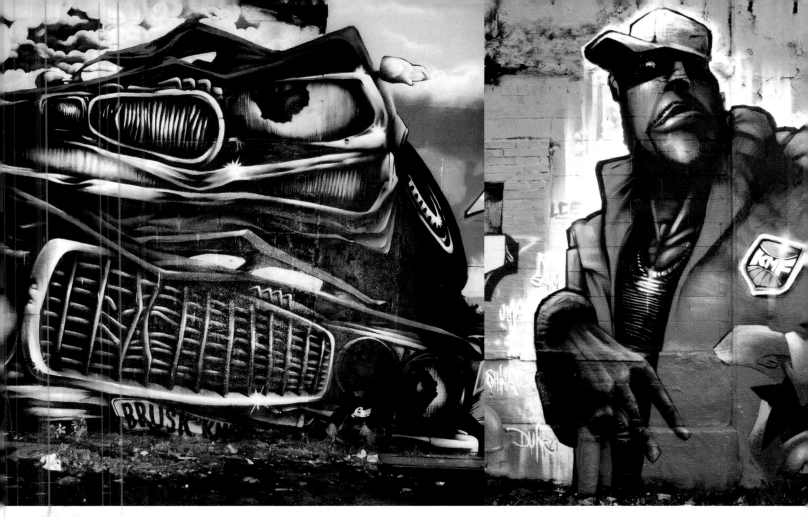

Details from frescoes by Brusk.

from **street** to **museum**

Jean-Michel Basquiat and Keith Haring are internationally famous names, and modern art museums are happy to host their work. They have long enjoyed star status in contemporary art. So much so, in fact, that their admirers may have forgotten that these two artists began on the street as taggers! Their stories, so similar yet so different, illustrate the dichotomy inherent in graffiti. Is it art? Is it vandalism? Their careers proved to be the spearhead of a new artistic movement, whose source was the street, and yet they clearly demonstrated the artistic power inherent in graffiti.

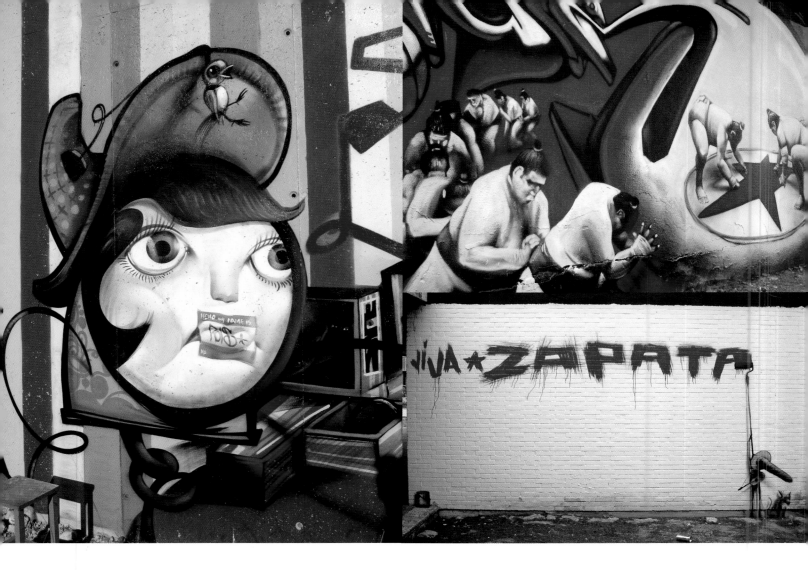

Born in Brooklyn in 1960 of a Puerto-Rican mother and a Haitian father already dead at the age of twenty-eight, Jean-Michel Basquiat revealed that his artistic talent came to the fore during the era of the great wave of graffiti

Above: Left, *Roys, My name is Rois (2004);* top right, *Logan-Ogre (2004);* bottom right, *Logan (2004).*
Right-hand page: *Details of frescoes by Logan (2004).*

writers, those pioneers of tag and graffiti, in 1970s New York. He remains the symbol of this wave that gathered in the subway and unleashed itself among the city's classiest galleries. He was deeply influenced by comic strip culture and it was natural he should make his contribution by exuberantly spraying trains with his signature, 'Samo'. With its copyright symbol surmounted by a crown, the

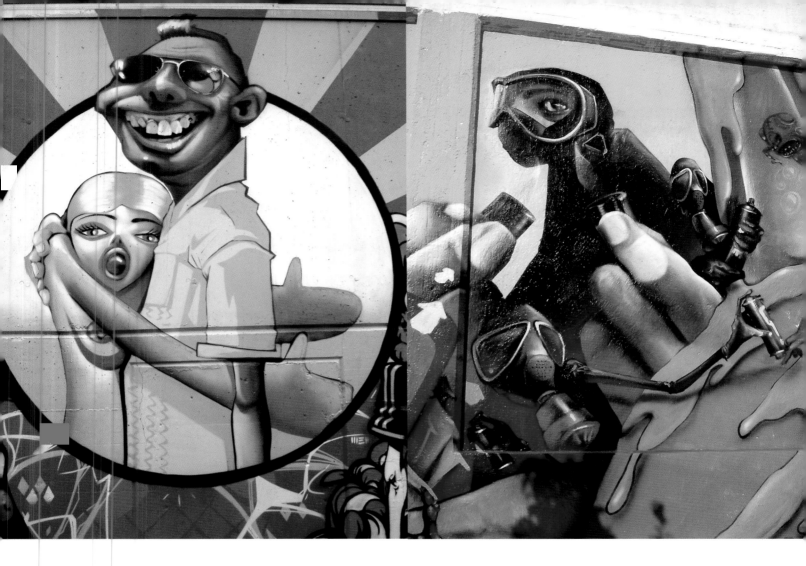

Samo *tag* rapidly became an icon. The young Basquiat's eccentric personality and marginal lifestyle – he was twenty at the time – also helped enthrone him as 'king of underground art'. His exploits revealed in particular a genius for spraying vengeful messages in carefully selected locations. For instance, a celebrated gallery-owner had the dubious pleasure one morning of coming downstairs to be met with the statement: 'SAMO as an end 2 playing at art with the "radical chic" on Daddy's $funds!' In need of finance, the art market was immediately hooked on the 'new wave': Basquiat and his Samo trademark were propelled to the heights of stardom in less time than it took to make his *tag*. From 1981, exhibitions followed one another in relentless succession.

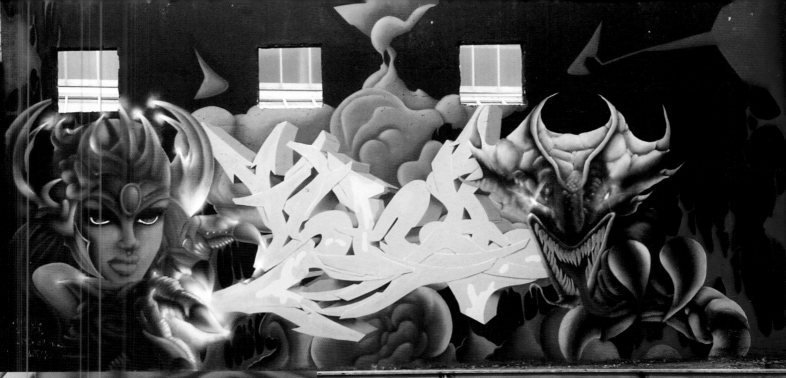

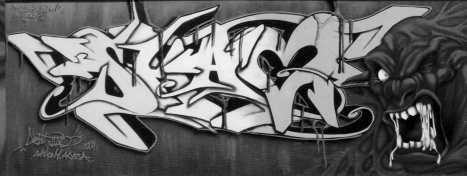

Details and frescoes, Sight-Shao (2004).

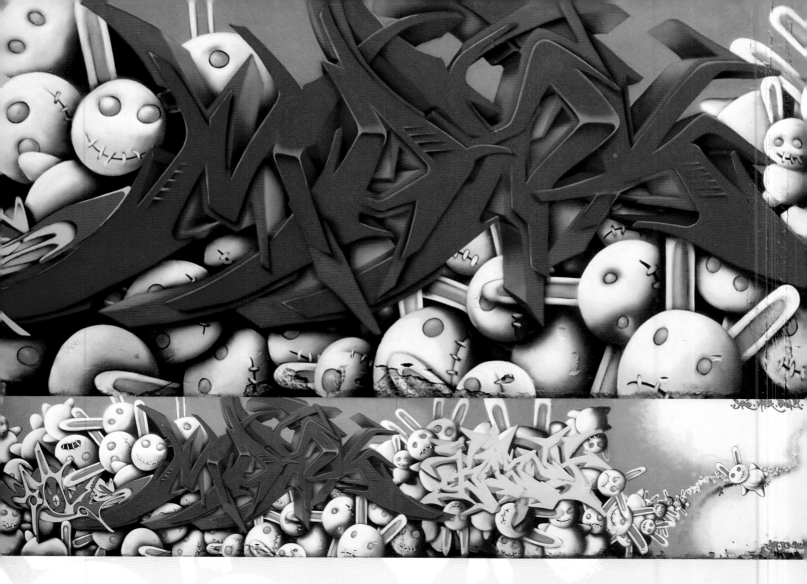

Keith Haring made no secret of *his* background. He was another *writer* from the underground culture of the subway who also met with success in the 1980s. White and middle-class, he passed a quiet childhood in Pennsylvania, at a distance from the New York ghettos.

Not far enough away, however, to deter him from launching *bombing* experiments as soon as he reached Manhattan. He was a good student, spending his time as much in the classroom of art school as on the subway. Born in 1959, he rapidly achieved fame by plastering the

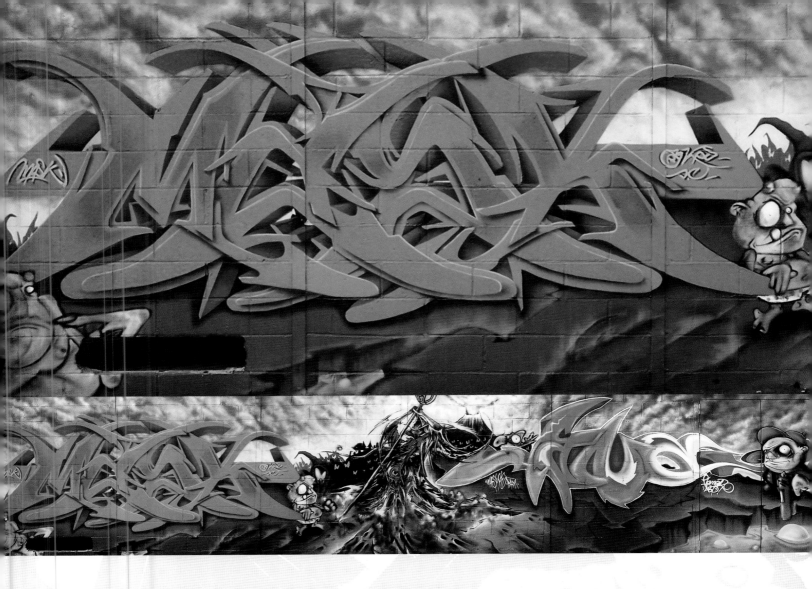

subway with what he termed 'modern hieroglyphics'. Obviously influenced by cartoons and comic strips, his naïve figures have toured museums and prestigious galleries of the world. Everyone must have seen his trademark image scribbled somewhere: a baby on all fours.

Wild style frescoes by Saké-Mask-Bosny **(left-hand page)** *and Mask-Mesy-Hamer* **(above)**. *(2004.)*

Top: *Yoda-Vida, 2 x 11 m/6 ft 7 in x 36 ft (2004);* **middle:** *Mask-Vida-Yoda, 3.4 x16.6 m/11 ft 2 in x 54 ft 6 in (2004)* **bottom:** *Mask-Vida-Yoda, 2 x 13.5 m/6 ft 7 in x 42 ft 3 in (2004).*

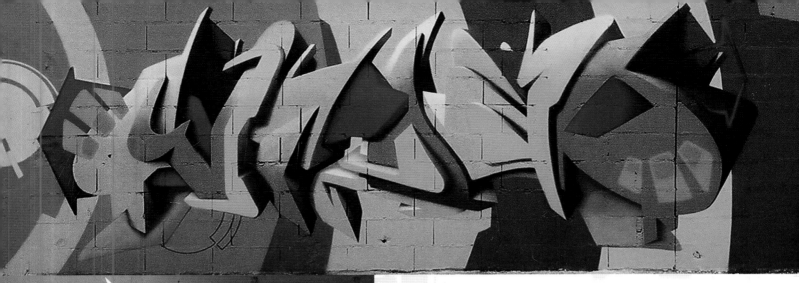

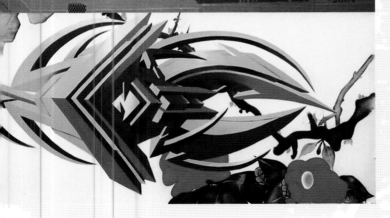

He never forgot his beginnings, continuing to paint walls, often free and for good causes, like his gigantic *fresco* in a children's hospital in Paris. He also possessed an innate gift for business: he was the first graffitist to consider commerce as the logical outcome of art. So, to his pictorial work we must add the stream of derived products he signed, from T-shirts to name-tags to watches, which he sold from his own shop in Soho. Even today dealers' faces light up at the sight of Haring graffiti. Keith Haring died of AIDS in 1990 at the age of thirty-one, but he remains the most striking symbol of the range of cultural influences which spawned graffiti.

Declaring your undying passion to the love of your life demands inventiveness and originality; it's not always easy to hit the right note. Never fear – love graffiti has come to the rescue of those besotted but bereft of inspiration. This charming innovation made its appearance on the walls of Paris in 2002.

They were the brainchild of André, one of the most innovative graffiti artists of his generation. A rebel since his first *bomb* attacks, He now offers his services on his Internet site. Once the commission is executed, the customer receives proof in the form of a photo and certificate. All that remains is for the happy pair to admire the work together!

graffiti
to order

state of the nation

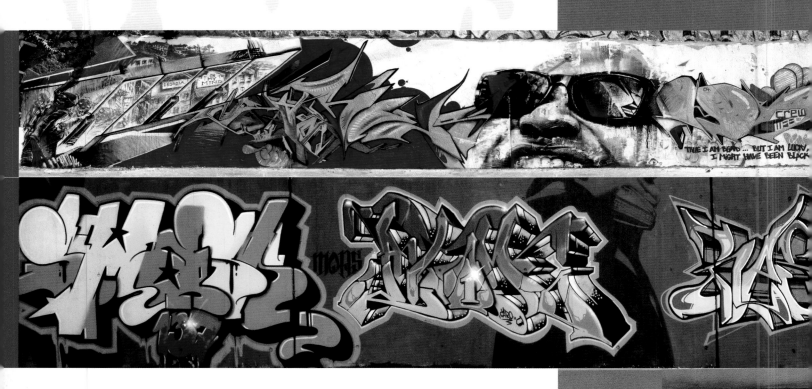

bombers
on **parole**

After its tentative beginnings, graffiti spread like a burning powder-trail across five continents in less than a decade to become an highly marketable commodity. Today it's a simmering art movement in a constant state of flux and progress. In the last twenty years, dozens of books on the subject have been published, fanzines have sprung up worldwide with the latest news updates, and several countries now stage flourishing festivals of graffiti art. Then there is the Internet where there are hundreds of relevant sites. Many graffitists have constructed their own sites to publicise their work – today's way of keeping

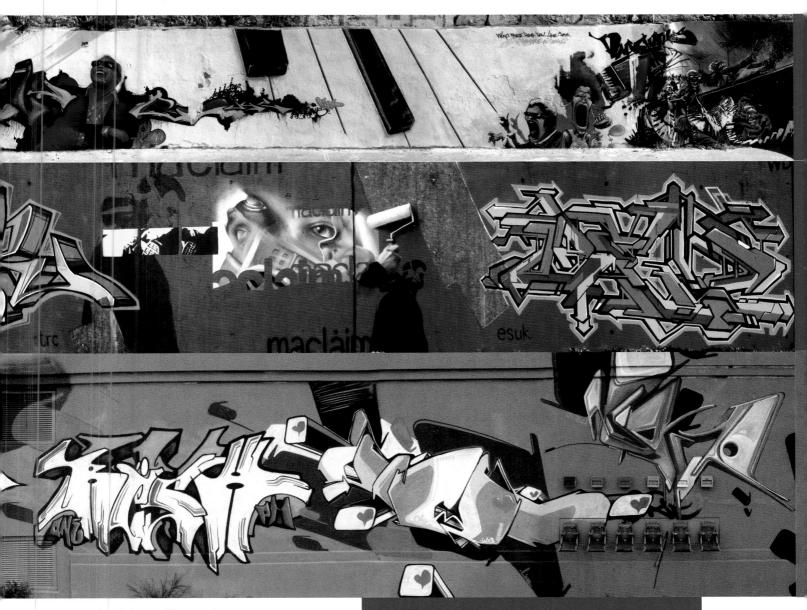

A quick glance at different trends.

Above: Top, *Nilko-Phaze-Heng-Jaw-Lime-Jaye,* Ray Charles *(2004);* middle, *Smash 137-Atom-Rusk-Case-Akut-Wow123, 35 x 2,5 m/115 ft x 8 ft 2 in (2003);* bottom, *Astus-Rish-Lime-Jaw (2004).*

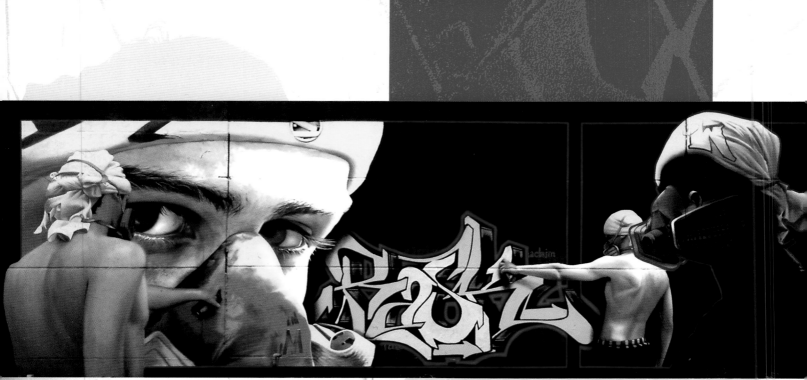

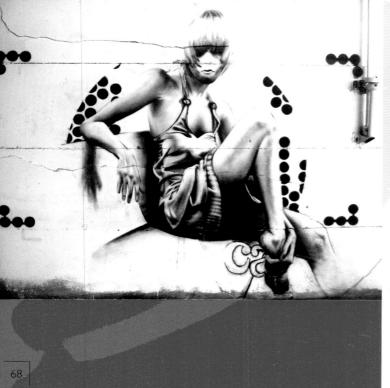

in the public eye, but all in the best business tradition! The Web also opens a wide window on the world and provides access to influences essential for inspiration. It's an indispensable means of communication to *writers* seeking to exercise their talents in countries where graffiti has a very much lower profile or where obtaining basic materials such as spraycans and caps is still virtually impossible.

An evermore draconian campaign of repression against street art – a vague term encompassing graffiti, *tags*, *frescoes*, *stencil graffiti*, stickers and unauthorised posters – has paralleled the rise of the movement. The courts in all countries are penalising graffitists more and more heavily with fines and prison terms, and a dangerous and disturbing game of cat-and-mouse has developed

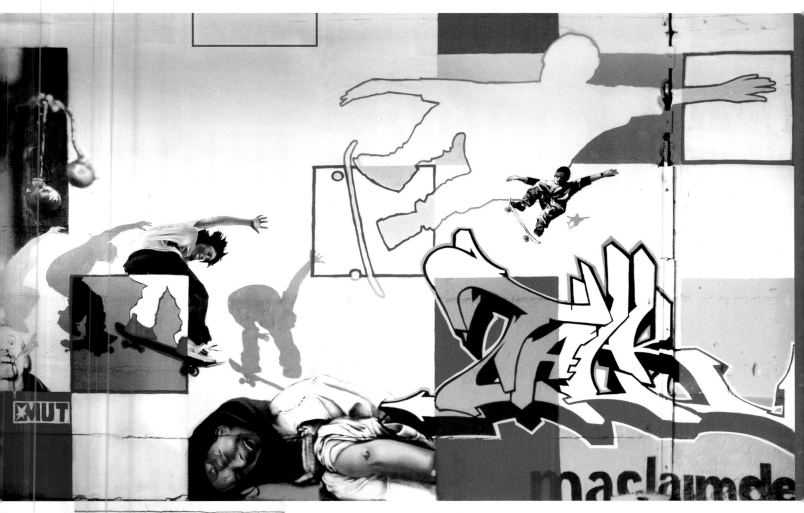

How's this for realism!

Left-hand page: Top, *Akut-Case-Rusk-Tasso*, Neu!,
13 x 4 m/42 ft 6 in 13 ft 1 in (2003);
bottom, *CoolCASE*, Überbelichtet, *1,8 x 2 m/5 ft 11 in x 6 ft 7 in (2003)*.

Above: *Akut-Case-Rusk-Tasso*, Crashkurs, *5 x 4 m/16 ft 5 in 13 ft 1 in (2003)*.

Opposite: *Akut*, *1,8 x 1,8 m/5 ft x 11 in (2003)*.

between *writers* and the police. Crime reports in the press illustrate this state of affairs, with some incidents ending in serious injury and, in at least one case, the death of *a writer*.

In France, repression has moved to the point where magazine publishers are no longer safe from legal action. In 2003, the SNCF (the French state transport company) issued proceedings against three specialist magazines claiming punitive damages for publishing photos of tagged rail wagons.

Judgement is still pending, but if it goes against the publishers, it would set a world precedent, for even in the USA the press has not yet been subject to court action. In the UK, the government has introduced legislation to forbid the sale of spraypaint to under-16s and has increased the penalties for being caught creating graffiti.

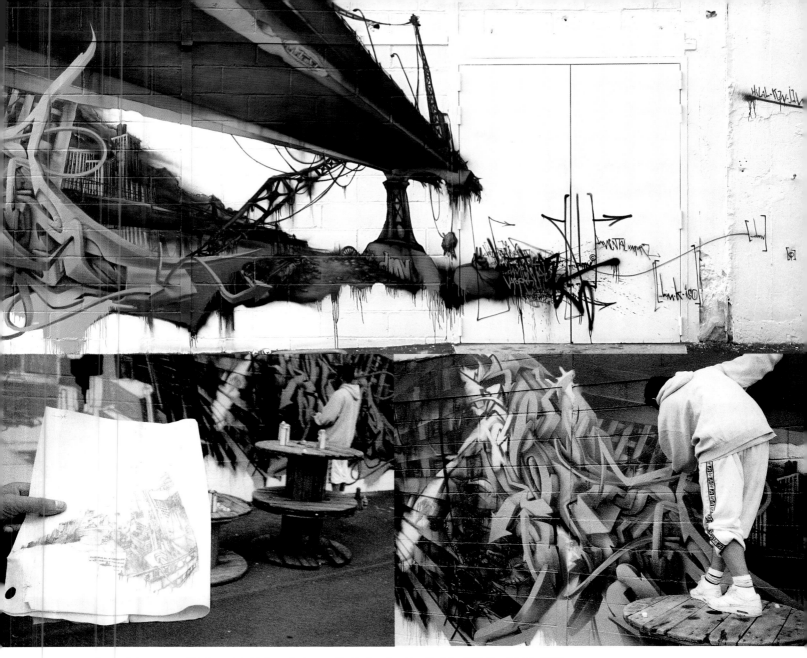

Science-fiction meets graffiti; the result is this fresco (Judgement Day) by Bom.K and Iso, 12 x 2.8 m/39 ft 4 in x 9 ft 2 in (2004).

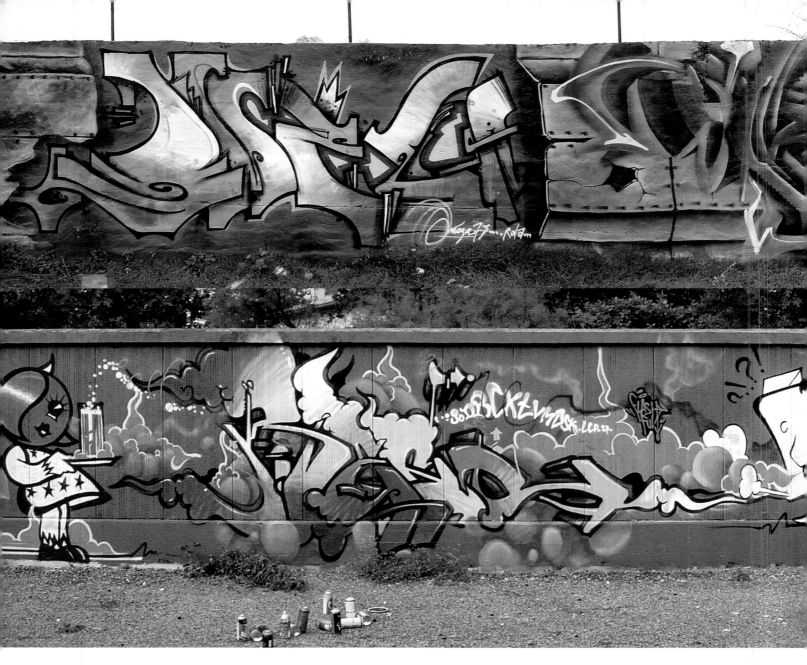

A pinch of explosive colours, small, sympathetic characters and a hearty dose of talent; mix together and what you have is a successful composition by Reso et Flik (2004).

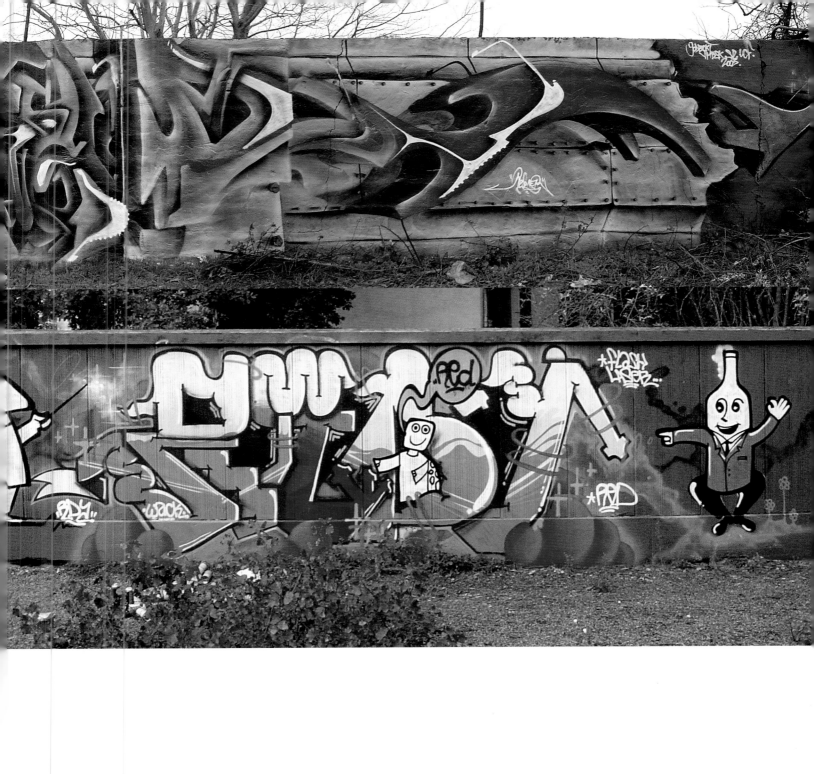

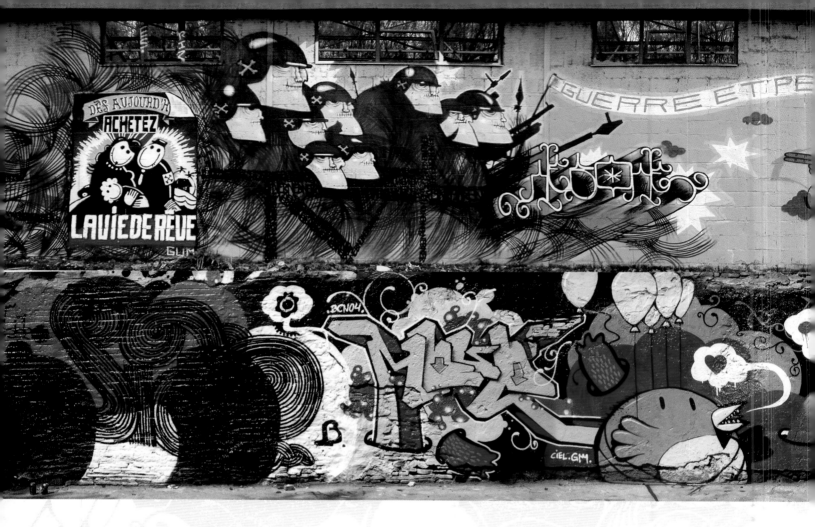

The politics of repression have not been without consequences for artistic expression. Many writers now choose to use only walls authorised for the purpose and limit their work to 'harmless' graffiti not liable to effacement. A few vengeful *tags* are still produced by purist colleagues who refuse to play a game they see as 'selling their souls to the devil'.

The debate has split the graffiti movement, but many members reject the criticisms, adopting a writer's lifestyle as a permanent challenge to the law. Others justify the right to involve themselves in commercial exploitation, citing the danger of seeing the movement taken over by computer graphics specialists from marketing agencies. By making money out of this type of collaboration, *writers*

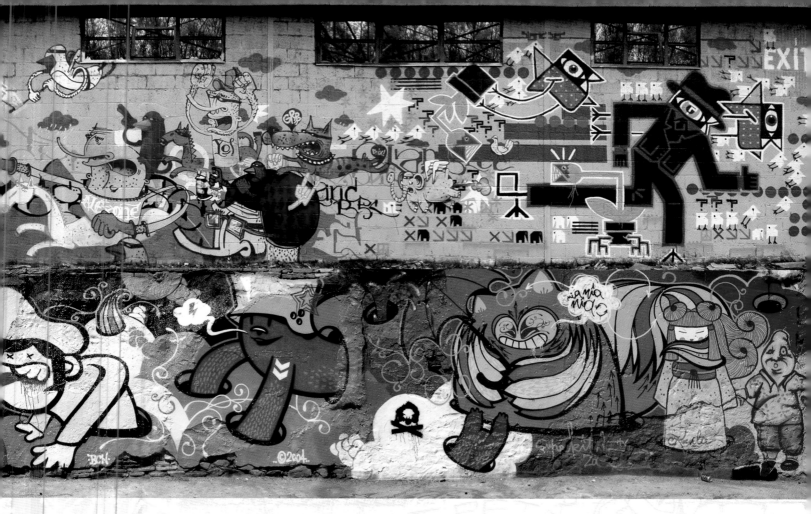

also acquire the means to live out their artistic lifestyle. The eradication of graffiti may have become an obsession with long-suffering city authorities, but has won little support from big business and designers who have viewed graffiti as a means of attracting the younger generation.

Top: *Graffers thrive on humour too. Here, for instance,* Guerre et pets *(In French,* War and Farts, *a word-play on* War and Peace) *by Gum-Nebor-Alëxone-Blanc Bec, approx. 3.5 x 24 m/11 ft 6 in x 78 ft 9 in (2004).*

Bottom: *A fresco packed with funny little people by Siao-Mode-Tabas-Captain Rouget-Flying Fortress-Supakitch-Koralie-Kazo.*

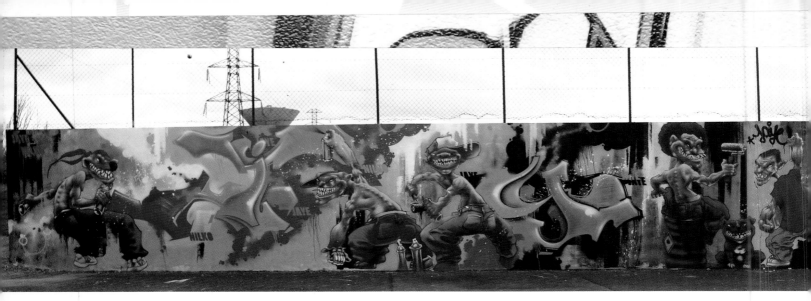

Clearly legible block lettering (large characters modelled on bubble style), 3-D style and *wild style* (interlocked or deconstructed) grew out of the early style. A figurative style, which was purely secondary at the start, took on a special importance and evolved into a class of its own, the graffiti on occasions consisting of a single figure.

Certain writers made a trademark of it and these familiar figures – readily identifiable by the casual observer, unlike so many *wild style frescoes* – sprang up all over town.

Odd characters with brilliant but disturbing smiles appear throughout this fresco – Psyko Tagueurs 2 *– a product of the imaginations of Jaye and Nilko (2004).*

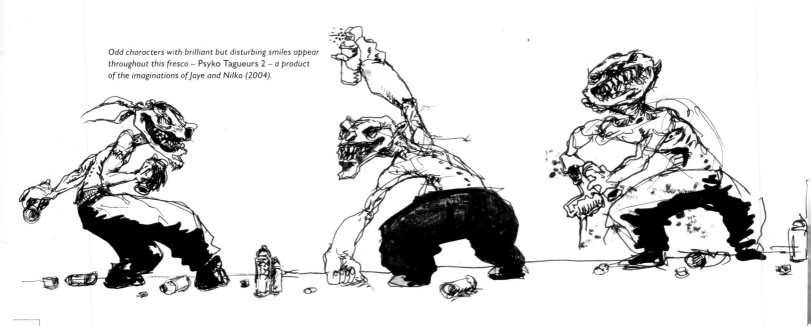

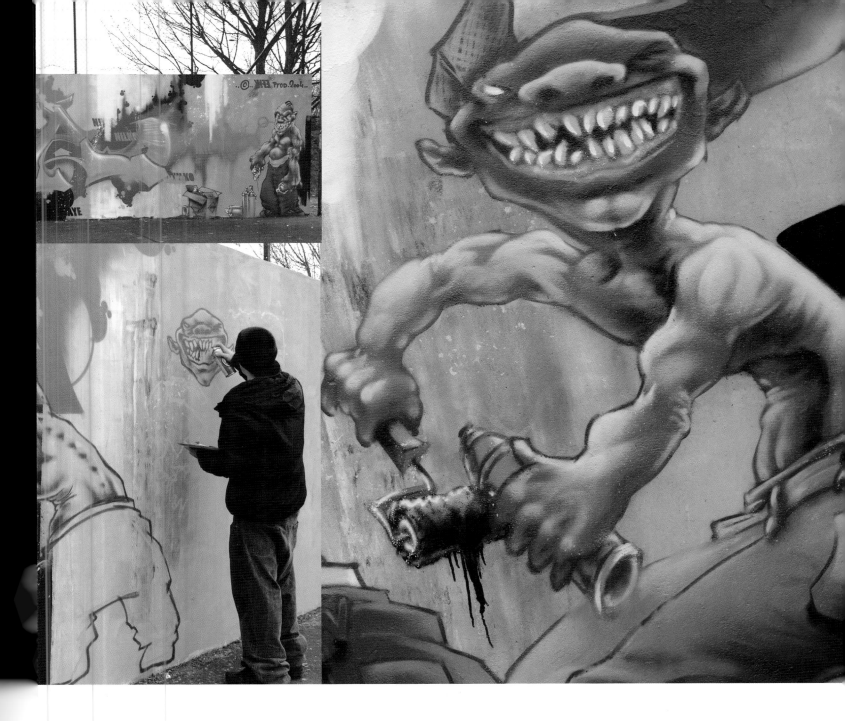

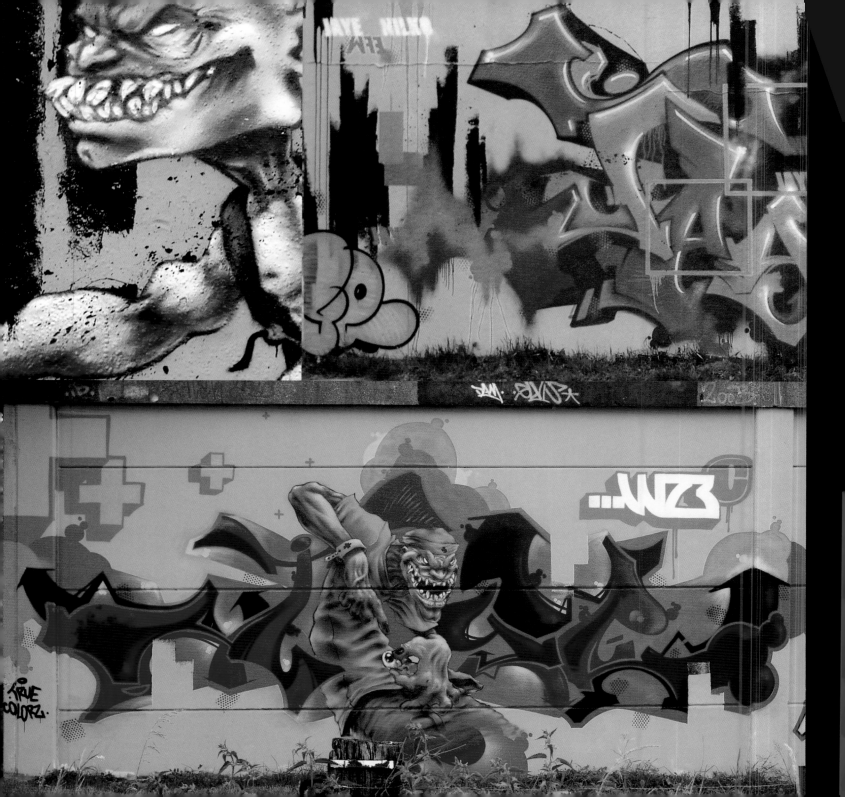

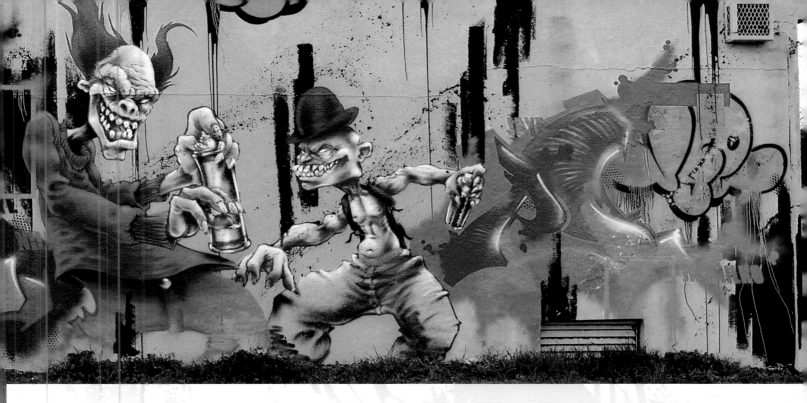

Some figures were treated with humour, some inclined towards photorealism; yet others evolved into pictograms or genuine logos. These techniques are still used today and have given graffiti a new dimension. Was this development another step forward in contemporary art or simply a refusal to be rolled over by the art world? As far as tools are concerned, the spraycan remains the mainstay of the *writer's* kit. But as styles move on, many have adopted new tools, including the airbrush: a device spraying liquidised colour and based on the use of compressed air; also posters and stickers. Oil-based and acrylic paints have also come into vogue. Will we soon be seeing watercolour graffiti? Even children's simple wax crayons have fallen into the *writers'* hands. Another twist has seen graffitists borrowing techniques of stencilling. The stencil is formed from a shape cut out of paper, cardboard or metal, and the paint applied by hand, brush or spraycan, allowing users to distinguish themselves from colleagues who continue with traditional spray methods. These developments have, of course, widened the *writers'* scope, drawing them closer to other street artists and gaining them access to avant-garde galleries.

Top: *another Jaye and Nilko effort:* Psyko Tagueurs 1.
Bottom: Jaye-Nilko, Chirurgie *(2004)*.
Double page following: *Reso (2004).*

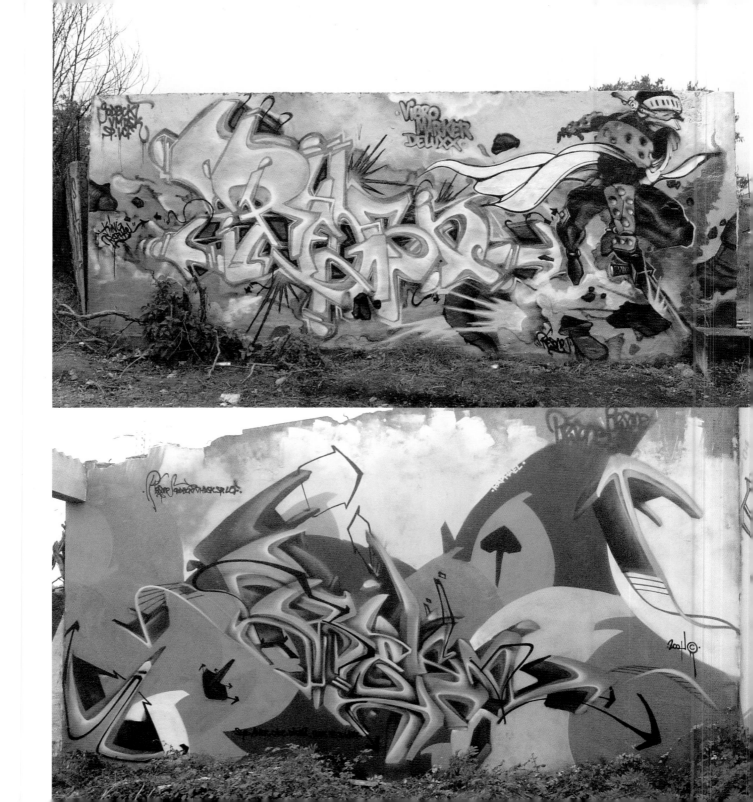

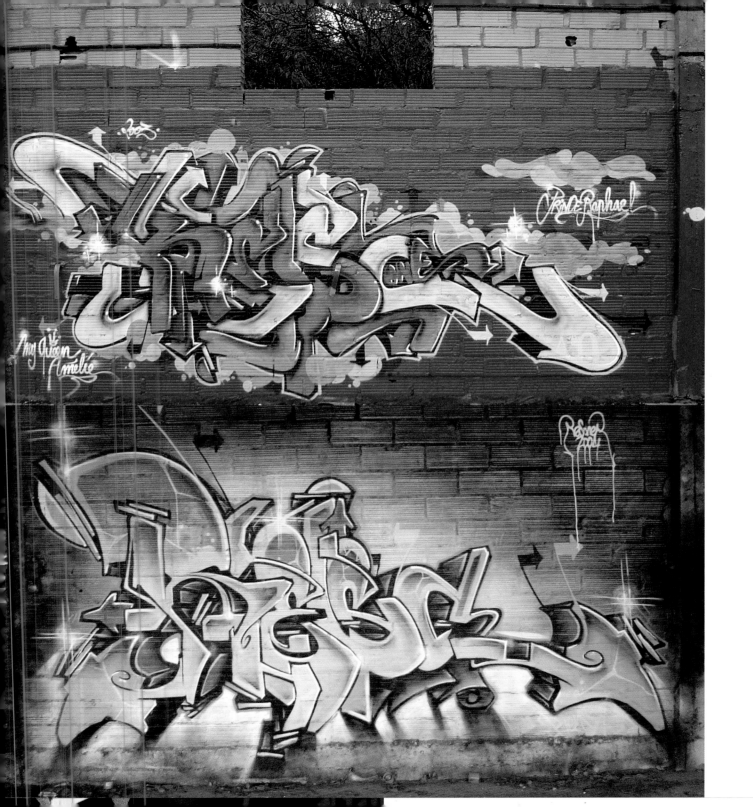

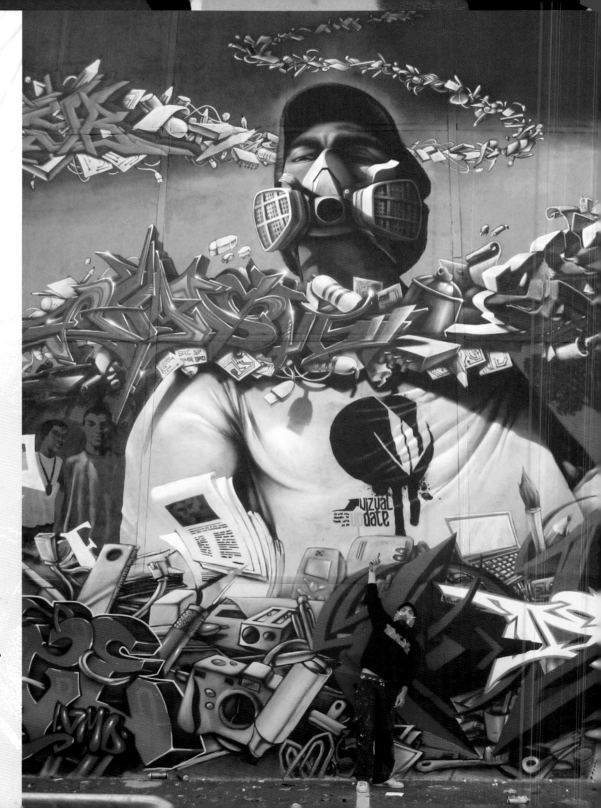

Graffs = vandalism?
Can anyone still believe
that after viewing
this sublime collective work?
SeyB-Brusk-Shadow-2rode-
Impact-Dezer-Yoda-Breze-
Rea (2004).

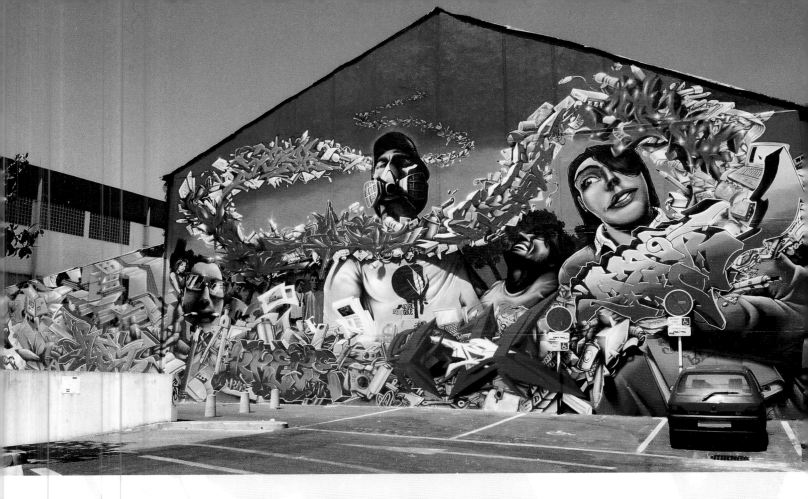

Further south, graffiti has found a fertile breeding-ground in the *favelas* of the Latin American capitals. The influence of US culture and problems of endemic poverty, drugs, crime and violence have acted as catalysts for the emergence of a graffiti scene over the last decade or so. This socio-economic context feeds the rage and passion inspiring South American graffitists, whose work possesses a vitality approaching that which fathered the movement in the ghettos of the Big Apple. *Writers* have found ways around the lack of money and the result is the

birth of new styles. One of the most active countries is Brazil. The work produced by artists there is typified by a naïve imagery based on traditional painting, itself related to the culture of Africa.

There can be no doubt that Europe – especially France – is the second most popular battleground of street art. France is a country profoundly attached to its special cultural traditions, and before the arrival of the tidal wave of *tags* and other *frescoes* of the hip-hop movement, street art was already claiming the walls thanks to

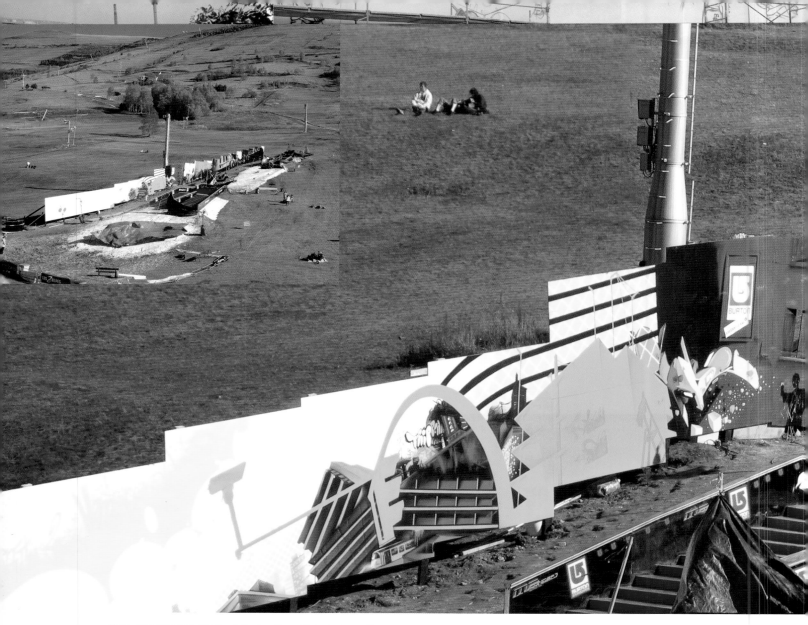

Above, opposite and double page following: *Team efforts also have a place in various festivals connected with urban culture. Here, a fresco by Jaw-Lime-Real-Heng produced during the 2004 World Snowboarding Championships in Deux Alpes, France. Details: double page following.*

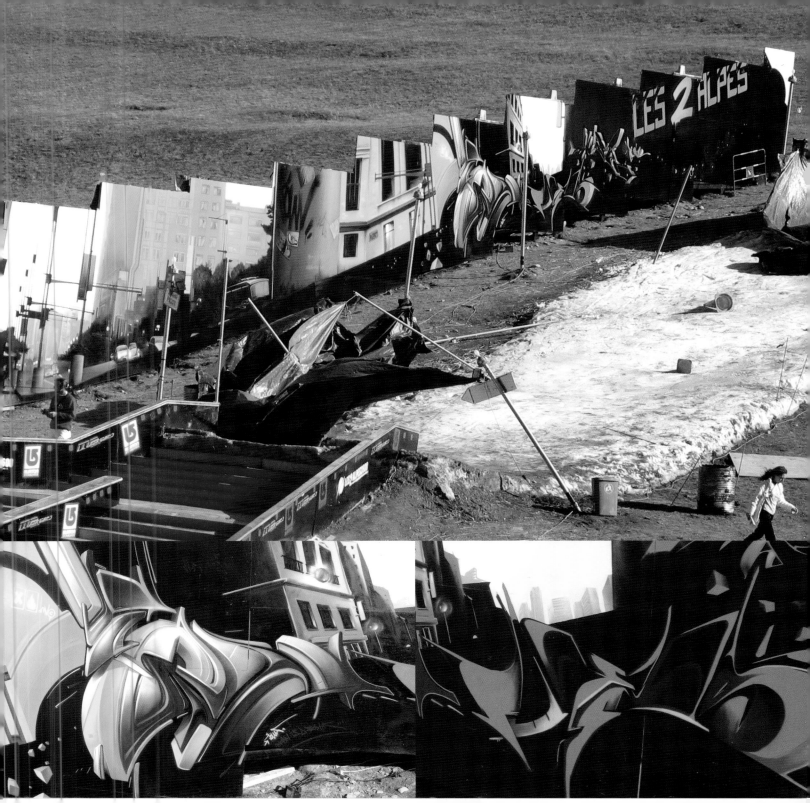

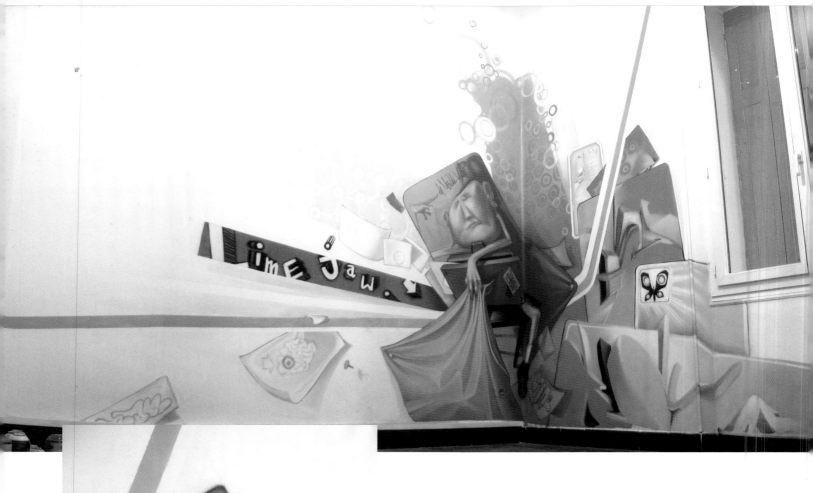

There is much latent talent in Asia and Africa, even if graffiti artists there don't enjoy such an aura of prestige as those in the US and Europe. Yet South Africa was the first country on the African continent to undergo the arrival of graffiti in 1984! Many European countries were not affected until ten years later. Like their South American counterparts, *writers* in Africa laboured under economic constraints. The lack of money made it hard to buy spraycans, scarcely everyday items in any case, and artists had to learn to work with paintbrushes and invent their own original styles.

Living conditions in the townships and other shantytowns of the big African cities imprinted street art with qualities all its own. In South Africa, the high crime rate and prevalence of gangs made things complicated for the lone graffitist – even more so than the state policy of removing graffiti, which proved too expensive. Creating graffiti art could, in fact, prove deadly dangerous, and it was quite normal for gang members to shoot at other graffiti gangs.

Some prefer graffiti in their bedroom! Lime-Jaw-Heng (2004).

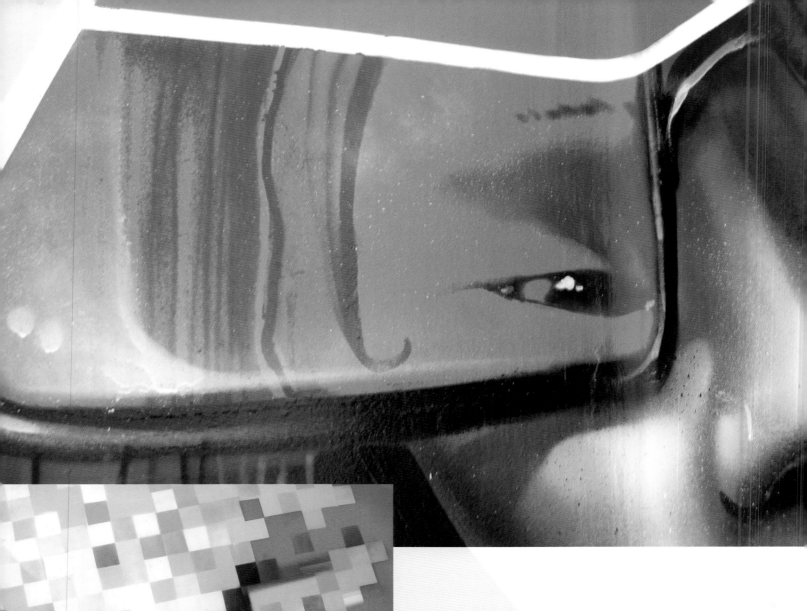

Outside the Republic of South Africa, graffiti remained a
minority movement in Africa. Street art was overtaken
by giant *murals* brilliantly exploiting a naïve format to
advertise garages, hairdressers or food stores.

On the other hand, the graffiti scene in Asia is vibrant with new talent. Deeply influenced by Western tendencies, *writers* also draw their inspiration from the calligraphy and artistic traditions of the Asian nations.

Rather than a common-or-garden reproduction of an old master, why not an original piece of contemporary art! Lime-Jaw (2004).

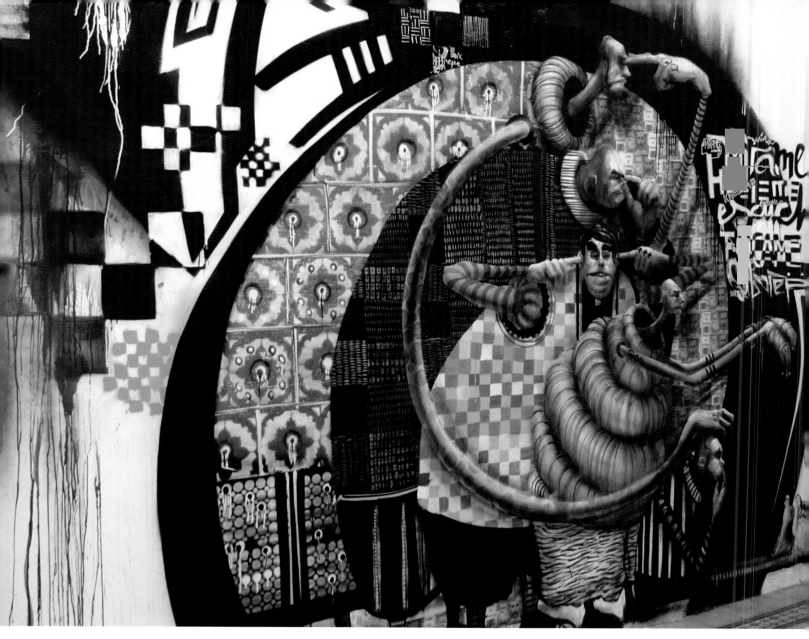

A wall interior redecorated by San: exhibition
in the Sala de estar, Seville, Spain (2004).

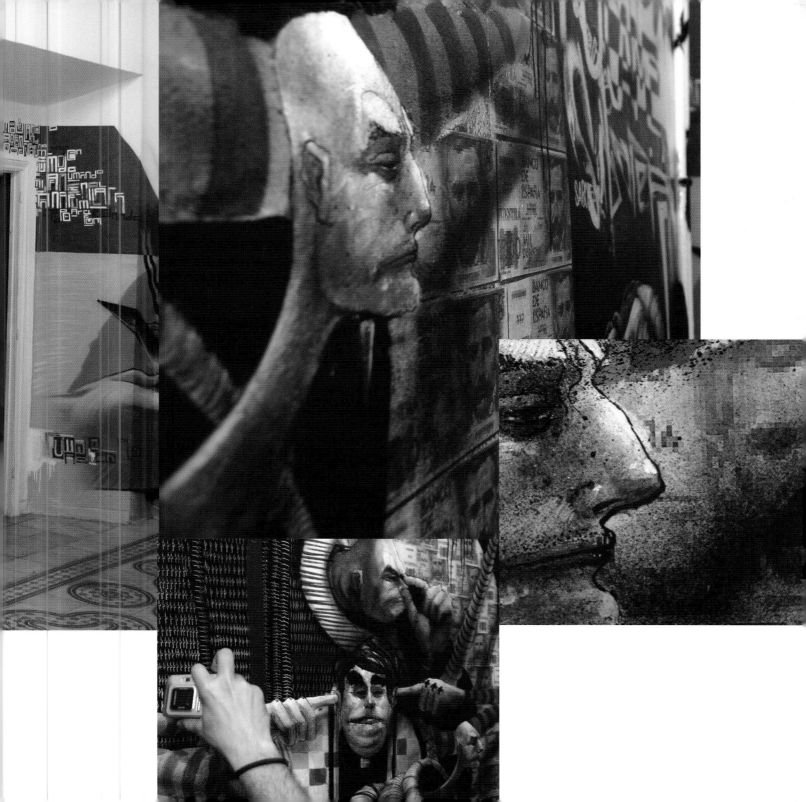

setting **the fashion**

Graffiti long ago invaded the world of fashion. Graffitists developed DIY designs and created their own wardrobe, printing individual or *crew tags* on T-shirts, jackets, trousers, sweatshirts and baseball caps. This cult took off at the same time as the trend for *bombing* trains and walls, clothing being a very valuable means of grabbing popular attention for a signature. *Writers* soon became eager to sport favourite *tags*, and the garment craze spread in widening circles from *crew* to *crew*, with some people starting to make a profit out of it by designing entire collections and opening their own boutiques.

It wasn't long before big business and the top fashion houses spotted the enormous potential in graffiti.

Who'd have imagined a hugely respected firm of luggage manufacturers with a world-famous logo adopting lettering derived from urban culture as *bombed*,

alongside other styles, on walls, trains and subway cars? The result was a line of bags marketed as Monogram Graffiti, from designs by Marc Jacobs, artistic director for Louis Vuitton, and Stephen Sprouse, New York underground artist. An icon was born. To specialists in the sector it was inevitable that fashion would become interested in street art. Graffiti remains the sole forbidden means of expression, with *writers* risking prison for unauthorised spraying: a subversive connection that

excites the fashion world, which loves to provoke – but without taking responsibility for any repercussions.

Less up-market but still a highly popular brand of streetwear, the leather firm Eastpack jumped on to the bandwagon in 2004, hiring an American (Seen) and a German (Seak) to help launch an exclusive, numbered series of two models. One was a pouch for spraycans (aptly named 'Tag'), the other a traditional rucksack. They made 1,250 examples of each. The design was

allegedly a response to particular clients' demands rather than an advertising coup. But one can see that marketing professionals know when they're on to a good thing. Marketing gimmicks and media ploys aside, some consider fashion gear as an alternative to the usual media for graffiti art. For instance, the designer Agnès B., who opened her art gallery to graffiti artists back in 1984. It was no surprise that in the autumn of 2002 she launched a mini-

with not just designers, but also the upper echelons of the food-processing industry. For others, this sort of collaboration was a blatant betrayal of graffiti's original spirit as a primarily unlawful activity. If *tagging* garments can be likened to the activities of ordinary artists and designers, then something vital was missing: the illegal dimension. The admission of this type of art into galleries has long been a subject of controversy within the movement and remains far from settled. To the most radical, the link-up between graffiti and fashion is a real

collection of T-shirts customised by Parisian graffiti artists. She then asked another six artists to help design one of her trendy accessories, the Byblos hat. The result was a sure-fire hit and led to a conveyor-belt of fresh designs each season.

For some, graffiti's foray into the world of fashion was not altogether a matter for rejoicing. There were those in it for publicity, pure and simple. They wanted to be seen and recognised for associating

mismatch. In their eyes, fashion houses had lost ground through sticking with the outdated concepts they'd been promoting since the 1980s so that hip-hop, the latest cultural phenomenon to hit the streets, came as a godsend. They milked it for all it was worth to rejuvenate their image and tap into new products. This could be described as a family dispute, perhaps, but one which has left its scars.

back to the
street

Like other fashions derived from hip-hop, graffiti developed far from the art schools. It was dynamic because it was self-taught, spontaneous in its rebelliousness, with a pronounced taste for provocation and an instinct for expressing the communal culture in which it had its roots. While rap, DJ-ing and dance became institutionalised and part of the commercial scene, graffiti has always lingered on the borderland of two worlds: the street world and the art world.

Graffiti has, then, remained faithful to its origins, deliberately confusing its tracks, and it is still as lively as ever on today's world scene. Its international spread, the growing number of graffiti artists — recognised or emerging — and the development of new styles reveal it is still in excellent health.

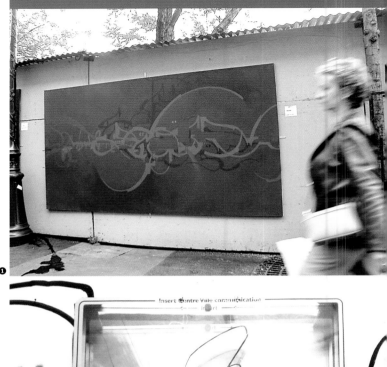

❶

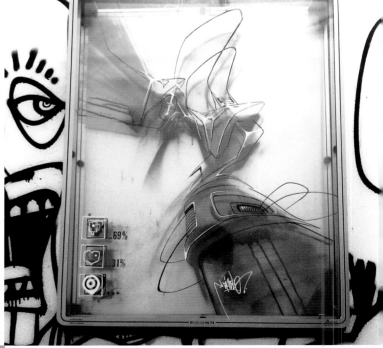

❷

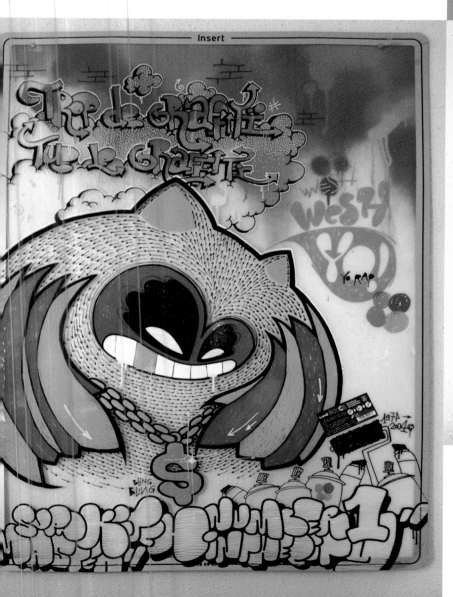

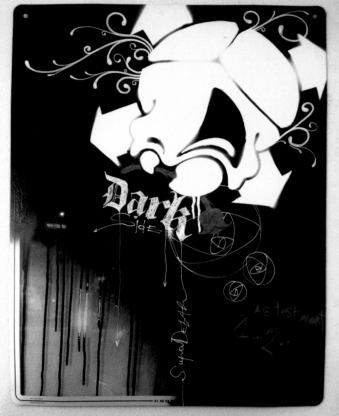

❹

Graffiti is also exhibited on traditional supports:

❶ *Spraycan on canvas, Alëxone,*
2.4 x 1.6 m/7 ft 10 in x 5 ft 3 in (2003).

❷ *Spraycan and acrylics on three plaques superimposed*
on Plexiglass, Diablo, 65 x 85 cm/2 ft 2 in x 2 ft 9 in (2004).

❸ *Mixed techniques on Plexiglass, Supakitch,*
Trop de graffiti tue le graffiti! 65 x 85 cm/2 ft 2 in x 2 ft 9 in.

❹ *Mixed techniques on Plexiglass, Supakitch, Dark Side,*
65 x 85 cm/2 ft 2 in x 2 ft 9 in (2004).

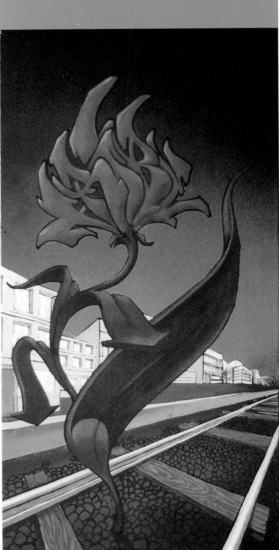

If marketing firms have ruthlessly re-appropriated lettering designs and adapted them to their own purposes, graffiti's stock still stands high. The illegal character of graffiti continues to make it an obscure object of desire. In spite of the privileged status accorded it by galleries and modern art museums, it is still hunted down and penalised.

❶ *Spraycan and acrylics on canvas, Trybe,* Fleur sauvage, *30 x 60 cm/12 x 24 in (2004).*

❷ *Spraycan on canvas, Yoda, 40 x 50 cm/1 ft 4 in x 1 ft 8 in (2004).*

❸ *Spraycan and acrylics on canvas, Jaye and Nilko,* Psyko Tagueurs 3, *1 m x 1 m/3 ft 3 in x 3 ft 3 in (2004).*

❹ *Spraycan on canvas, Sight, 68 cm x 68 cm/2.2 ft x 2.2 ft (2004).*

❺ *Spraycan on wood, Akut-Case-Rusk-Tasso- Scotty76, 6 x 4 cm/2½ x 1½ in (2003).*

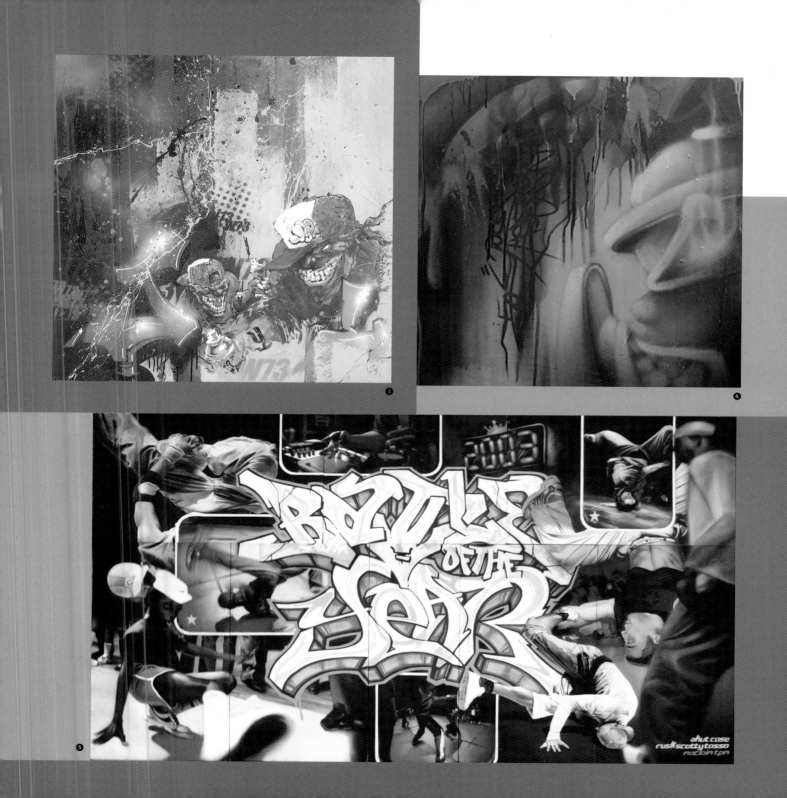

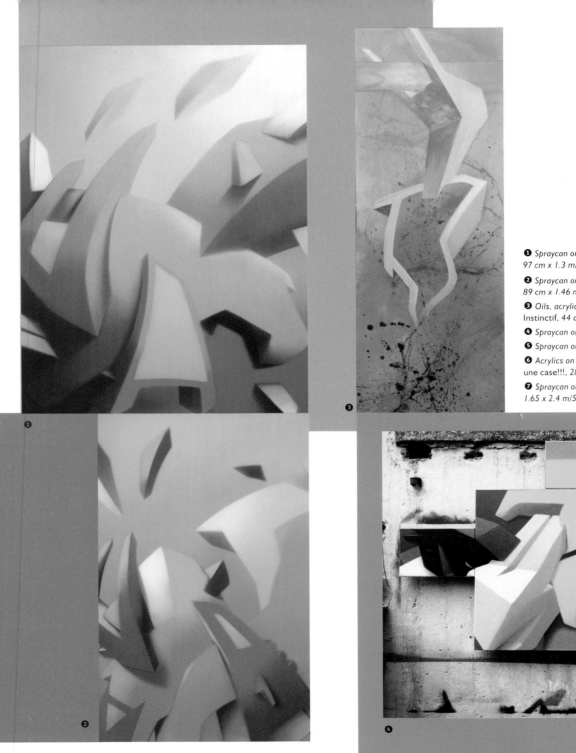

❶ *Spraycan on canvas, Vida, Velours, 97 cm x 1.3 m/3 ft 2 in x 4 ft 3 in (2004).*

❷ *Spraycan on canvas, Vida, Up to the sky, 89 cm x 1.46 m/2 ft 11 in x 4 ft 9 in (2004).*

❸ *Oils, acrylics and spraycan on wood, Vida, Instinctif, 44 cm x 1.22 m/1 ft 5 in x 4 ft (2003).*

❹ *Spraycan on canvas, Vida, Dvian (2001).*

❺ *Spraycan on canvas, Vida, Pugnacité (2001).*

❻ *Acrylics on canvas, Vida, Il lui manque une case!!!, 28.4 x 28.4 cm/11 in x 11 in (2004).*

❼ *Spraycan on canvas, Vida, La forge DNUP, 1.65 x 2.4 m/5 ft 5 in x 7 ft 10 in (2003).*

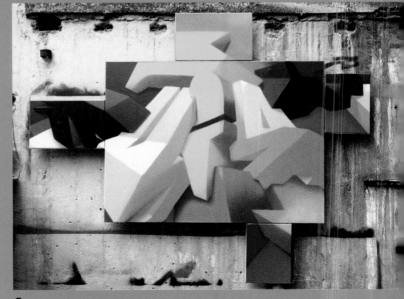

The survival of graffiti art and its amazing capacity for self-regeneration are most certainly due to this state of conflict which, from very beginning has seemed to be the very essence of the activity. So graffiti fans, be of good cheer: it's still war to the death, and the end is a long way off yet!

6

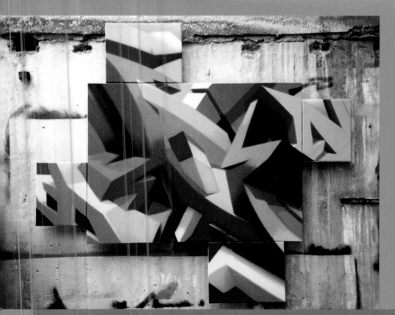

5

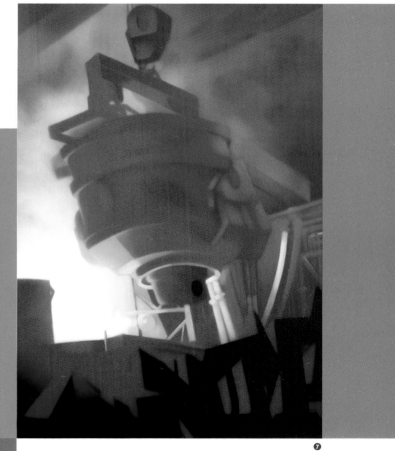

7

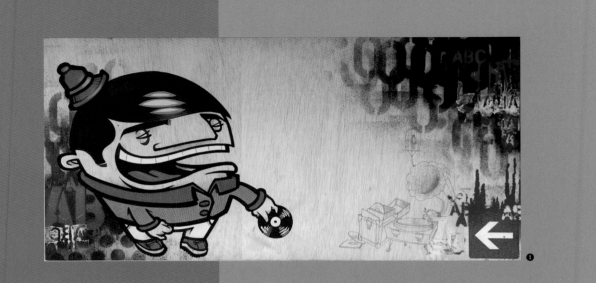

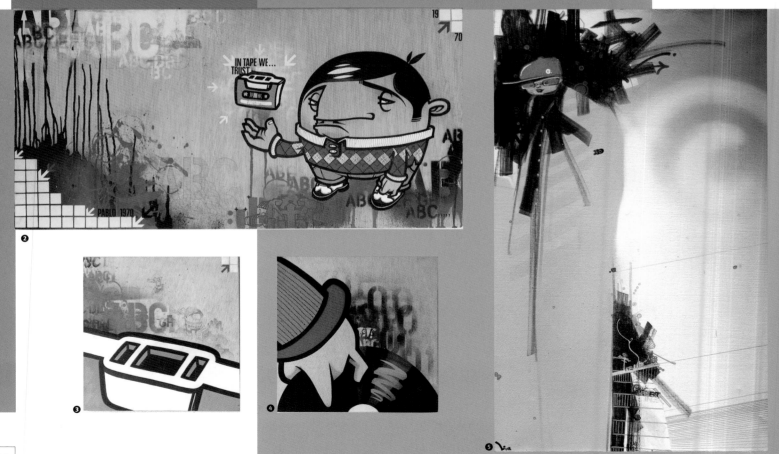

❶ and **❷** *Mixed techniques on wood, Zeta,*
1 m x 40 cm/3 ft 3 in x 1 ft 4 in (2004).

❸ and **❹** *Mixed techniques on wood, Zeta,*
30 x 30 cm/12 in x 12 in (2004).

❺ *Spraycan, posca and felt-tip on canvas, Lime,*
35 x 60 cm/14 x 24 in.

❻ *Spraycan, posca and felt-tip on canvas, Lime,*
35 x 45 cm/14 x 18 in.

❼ *Mixed techniques, Most.*

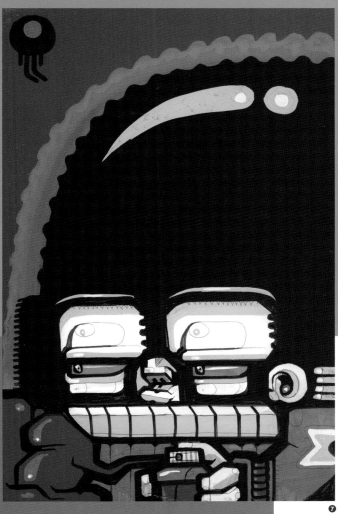

❼

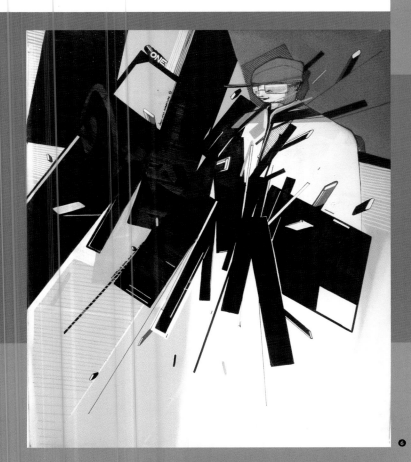

❻

❶

❶ *Acrylics, posca and pen on canvas, Brusk,*
40 X 70 cm/1 ft 4 in x 2 ft 4 in (2003).

❷ *Mixed techniques on canvas, Lksir,*
Au volant de sa caisse! (sur mon genou),
1 m x 1.80 m/3 ft 3 in x 5 ft 11 in (2003).

❸ *Acrylics and pen on canvas, Brusk, Fanny,*
70 x 25 cm/2 ft 4 in x 10 in (2004).

❹ *Spraycan on canvas, Brusk, Uma,*
1.5 x 1.5 m/4 ft 11 in x 4 ft 11 in (2004).

❺ *Spraycan on canvas, Simone,*
1 x 1.5 m/3 ft 3 in x 4 ft 11 in (2004).

❷

3

4

5

❶ *Spraycan on canvas, Shao,*
60 cm x 1.20 m/24 in x 3 ft 9 in (2004).

❷ *Spraycan on canvas, CoolCASE, Beware!,*
2 x 50 x 50 cm/19½ x 19½ in (2003).

❸ *Spraycan on canvas, Akut, Oil,*
1 m x 80 cm/3 ft 3 in x 2 ft 7 in (2003).

❹ *Mixed techniques on canvas, Tasso, Grün-braun,*
60 x 50 cm/24 x 20 in (2003).

❺ *Spraycan, felt-tip and posca on canvas, Ogre,*
15 x 25 cm/6 in x 10 in (2004).

④

③

⑤

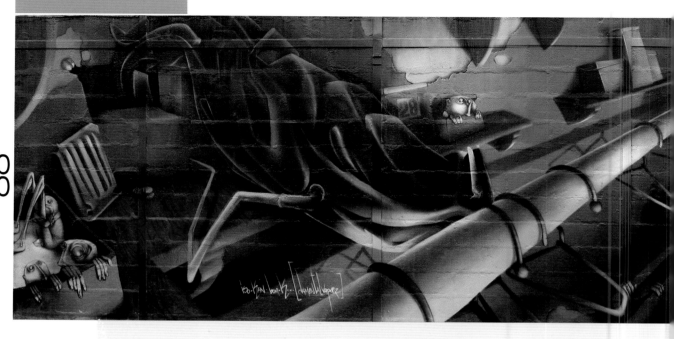

glossary

for the novice tagger

Part of the fun of graffiti art is the technical jargon. Let's start with the fundamentals: the various styles. Favouring one of them is to express your personality by associating yourself with a school of graffiti.

Bubble style is a sort of homage; a nod to the founders of graffiti. Developed in New York in the 70s, its trademark is an expanded form of lettering, as if imitating bubbles. At the opposite extreme is **wild style**, involving much more complexity. Characteristically it's made up of tangled letters extraordinarily hard for outsiders to make sense of. Another favourite technique is **stencil graffiti**. The idea is very simple: using cardboard, you cut out one or more shapes (or letters) of any size, and then place the stencil against the medium you want to paint or spray. The word **mural** is occasionally used in this connection.

Recently **post-graffiti** and **neo-graffiti** have become buzzwords among the initiated. They refer to a new approach based on borrowed techniques, and go beyond the normal lettering styles.

Then there's **logo graffiti**, swiftly becoming the coolest of the cool. The idea is to create logos as spectacular as possible, writers' trademarks, if you like.

Making a **fresco** – not the exclusive prerogative of writers – simply means creating a piece of wall art, more or less extensive in scale, using a brush or spraycan. On the

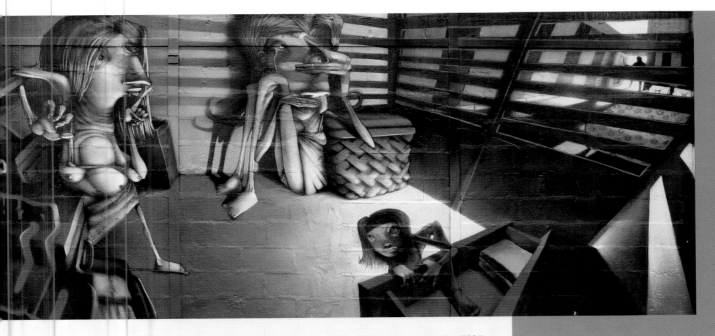

Fresco by Iso, Kan and Bom.K, Chin Check, 11 x 2.50 m/36 ft 1 in x 8 ft 3 in (2004).

other hand an **end-to-end** is strictly defined as a graffiti stretching from one end of a wagon to the other below window-level. **Bombing** is the prolific painting of a surface. A **fill-in** is a technique involving colouring in the centres of the lettering. Finally, there's the **throw-up**, a hastily executed graffiti using only one colour.

A **piece** or **masterpiece** is a large-scale, highly coloured and complex work. Lettering is the chief component and defining symbols such as

hearts or vines may be included. A particularly high quality piece is called a **burner**.

Graffiti artists term themselves **writers**. A **tag** is a writer's signature. A **crew** is the term for a group or gang of graffiti artists, also sometimes known as a **clique**. Crews are headed by **kings** and **queens,** who rate members by the quality of their pieces as well as by their loyalty to the crew.

So, maybe you fancy trying your hand at your favourite style? Before getting

stuck in, be aware that, unless it's an authorised site, you are breaking the law. Defacing walls, trains or any other part of private property may lead to you being arrested and fined – or even sent to prison! So, decorate your possessions or create your own website but don't be tempted to try out your skius on public property.

bibliography

123Klan, Paris, Pyramyd, 'Design & Designer' series, 2003.

Balzac, Honoré de, *Ferragus*, Lightning Source UK Ltd., 2004.

Brassaï, *Graffiti*, Paris, Flammarion, 2002.

Chalfant, Henri; Prigoff, *Spraycan Art*, London, Thames & Hudson, 1987.

Cooper, Martha; Prigoff, James, *Subway Art*, London, Thames & Hudson, 1984.

Courtin, Maxime; Arin, Forner, *Welcome to Colors Zoo*, Colors Zoo, 2004.

Ganz, Nicholas, *Graffiti World: Street Art from Five Continents*, London, Thames & Hudson, 2004.

Mailer, Norman, *Graffiti de New York*, Paris, Éditions du Chêne, 1974.

The Faith of Graffiti, Greenwood Publishing Group Inc., 1974.

Manco, Tristan, *Stencil Graffiti*, London, Thames & Hudson, 2002.

Street Logos, London, Thames & Hudson, 2004.

Riout, Denys; Gurdjian, Dominique; Leroux Jean-Pierre, *Le Livre du graffiti*, Paris, Syros/Alternatives, 1990.

The publisher's grateful thanks go to **Laurent Farcy.**

web sites

www.graffiti.org
www.streetlogos.com
www.stencilgraffiti.com
www.subwayoutlaws.com

graffiti artists featured in the book

www.alexone.net
www.vidaconcept.com
www.damentalvaporz.com
www.maclaim.de
www.xnos.net

acknowledgements

Romuald Abel - Alëxone - Bom.K - Brusk - Case - Dems - Diablo - Heng - Jaw - Jaye - Kan - Legz - Lime - Lksir - Logan - Mask - Nilko - Ogre - Lionel Olives - Fabrice Paulet - Peack - Reso - Rish - Roys - San - Shao - Sight - Simone - Supakitch - Trybe - Vida - Yoda.

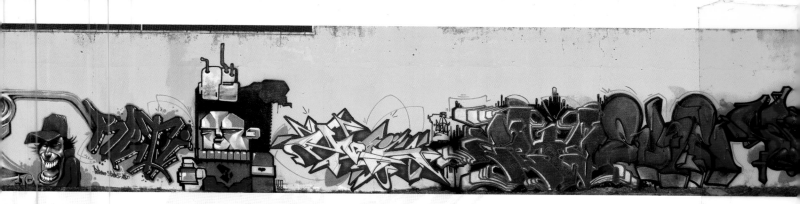

photographic credits

Alëxone 16, 21, 23, 42, 43, 74-75 t, 76-77 t, 104 t. **Bad Mouse Grafixx** 80 t, 81, 82, 83, 107 tl. **Bom.K** 2, 25 bl, 70-71 t, 116-117. **Brusk** 20, 50, 51, 88, 112 l, 113 t, 113 l. **Case** 10 br, 11 1st band l, 22 tl, 66-67 m, 68, 69, 107 b, 114 r, 115 l, 115 tr. **Henry Chalfant** 8. **Diablo** 10 tl, 10 tr, 24 t, 24 b, 26, 27, 104 b. **Nicolas Gzeley** 12 b, 30, 31, 86, 87. **Iso** cover 1 recto/verso, cover 4 recto, 1, 9 l, 70 b, 71 bl, 71 br, 102, 103. **Kan** 28, 29, 90. **Lime** 40, 41, 64-65 r, 66-67 t, 66-67 b, 78, 79, 92, 93, 94, 95, 96, 97, 98, 99, 110 br, 111 l. **Lksir** 22 bl, 44, 45, 46, 47, 76-77 b, 112 br. **Logan** 52 tr, 52 br, 53. **Mask** 58, 59. **Most** 13 tl, 38, 39, 111 r. **Nilko** 80 b. **Ogre** 36, 37, 91 t, 115 br, 120-cover. 4 verso t. **Lionel Olives** 4-5, 6-7, 118-119. **Fabrice Paulet** 32, 33 r. **R2Rien** 33 tl, 48, 64 l. **Reso** 11 4th band, 25 tl, 72-73, 84-85. **Rish** 14, 15, 25 r, cover. 4 verso b. **Roys** 12 t, 13 bl, 13 br, 52 l. **San** 100, 101. **Sight** 54, 55, 56, 57, 107 tr, 114 l. **Simone** 10 bl, 11 1st band r, 13 tr, 113 br. **Supakitch** 17 t, 17 b, 18, 19, 74-75 b, 105. **Trybe** 11 3rd band, 62, 63, 106 l. **Vida** 22 r, 108, 109. **Yoda** 9 r, 11 2nd band, 34, 35, 49, 60-61, 89, 91 b, 106 r. **Zeta** 110 t, 110 tl, 110 bl, 110 bm.

Every effort has been made to obtain the necessary permissions.
Any errors or omissions made known to us will be corrected in the next edition.

In partnership with

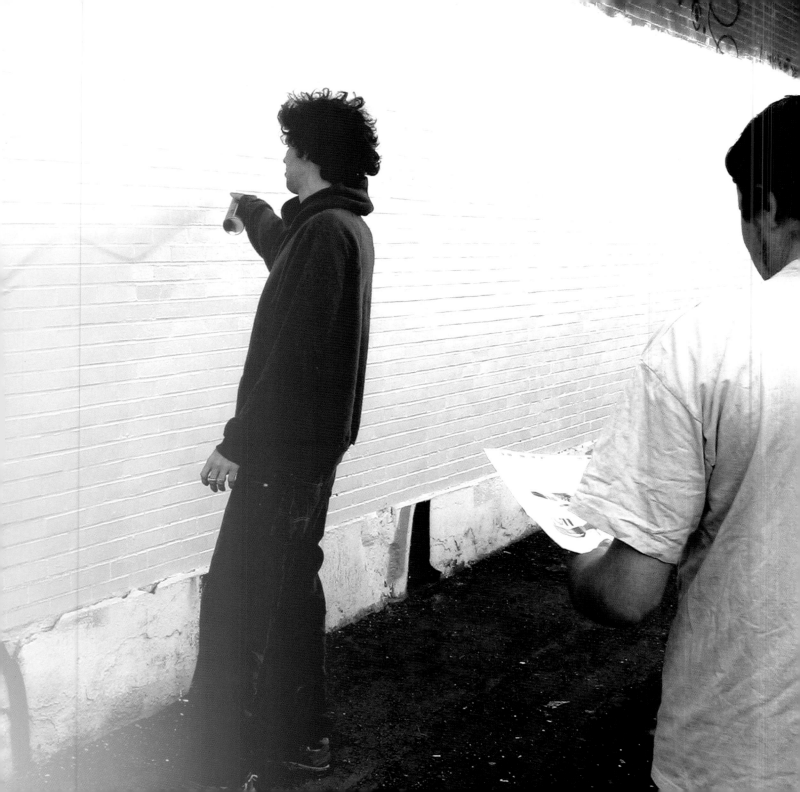